Giovanni Bellini's
Dudley Madonna

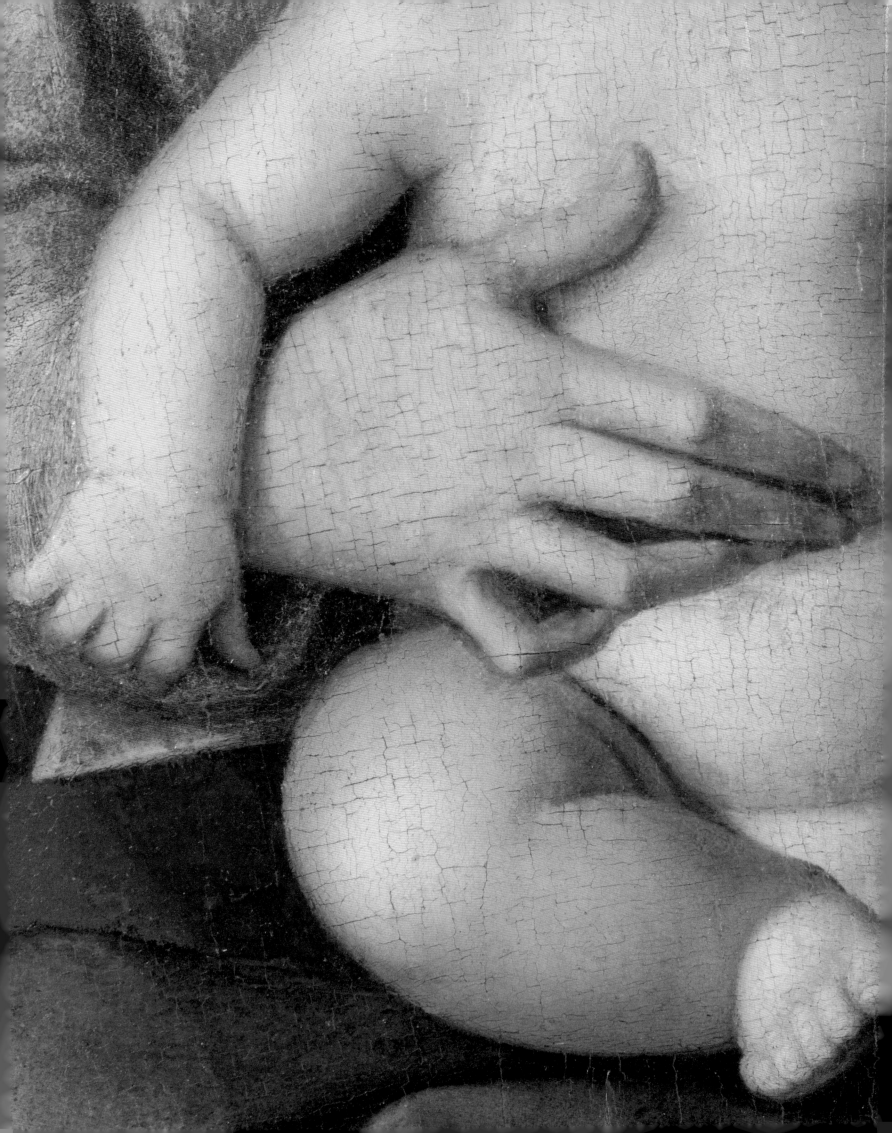

Giovanni Bellini's Dudley Madonna

ANTONIO MAZZOTTA

Paul Holberton publishing

ISBN 978 1 907372 46 9

British Library Cataloguing in Publication Data
A catalogue record for this book is available from
the British Library

Produced by Paul Holberton publishing
89 Borough High Street, London SE1 1NL
www.paul-holberton.net

Translated from the Italian by Carol Lee Rathman

Designed by Laura Parker

Origination and printing by E-Graphic, Verona, Italy

ACKNOWLEDGEMENTS

The author is grateful to the patron of this book, who has been actively and stimulatingly involved in every detail of the project and who has generously given him a great opportunity for research and for the independent expression of his ideas.

Special thanks, for having followed every stage of this project, go to Giovanni Agosti, Jennifer Fletcher and Francis Russell.

The author is grateful also to Alessandro Bagnoli, Alessandro Ballarin, Roberto Bartalini, Luciano Bellosi, Eduardo Botti, James Bruce-Gardyne, Tilmann Buddensieg, Norman Coady, Federica D'Amico, Ingeborg De Jongh, the Earl of Dudley, Everett Fahy, Marzia Faietti, Marco Flamine, Afdera Franchetti, Bianca Franchetti, Arturo Galansino, Paul Holberton, Laurie Kind, Denise King, Teresa Kittler, Aleramo Lanza, Giorgia Mancini, Susy Marcon, Gabriele Mazzotta, Martina Mazzotta, Piotr Michałowski, Carolyn Miner, Laura Parker, Ralf Peters, Carol Plazzotta, Fabrizia Previtali, Gabriele Reina, Cristina Rodeschini, Vittoria Romani, Xavier Salomon, Cornelia Sattelmair, Christoph Schuringa, David Scrase, Erica Sergio, Francesca Sidhu, Jacopo Stoppa, Marco Tanzi, Carol Togneri, Johnny Van Haeften, Nicola Wolff, Barbara Wood, Martin Wyld and Matteo Zarbo.

The author would like to thank also the staff of the National Gallery Library, London, as well as the generosity of the following institutions: Archivio di Stato di Bologna, Bologna; Biblioteca dell'Archiginnasio, Bologna; Local History Service, Coseley; Kunsthistorisches Institut, Florence; Witt Library, Courtauld Institute of Art, London; The National Gallery Picture Library, London; the Getty Research Institute Library, Los Angeles; Zentralinstitut für Kunstgeschichte, Photothek, Munich; The Frick Art Reference Library, New York; Biblioteca Marciana, Venice; the staff of the Fondazione Cini library, Venice; The National Gallery of Art Library, Washington.

Last, but not least, the author is grateful for the highly professional and kind support of the staff of E-Graphic, Verona.

Contents

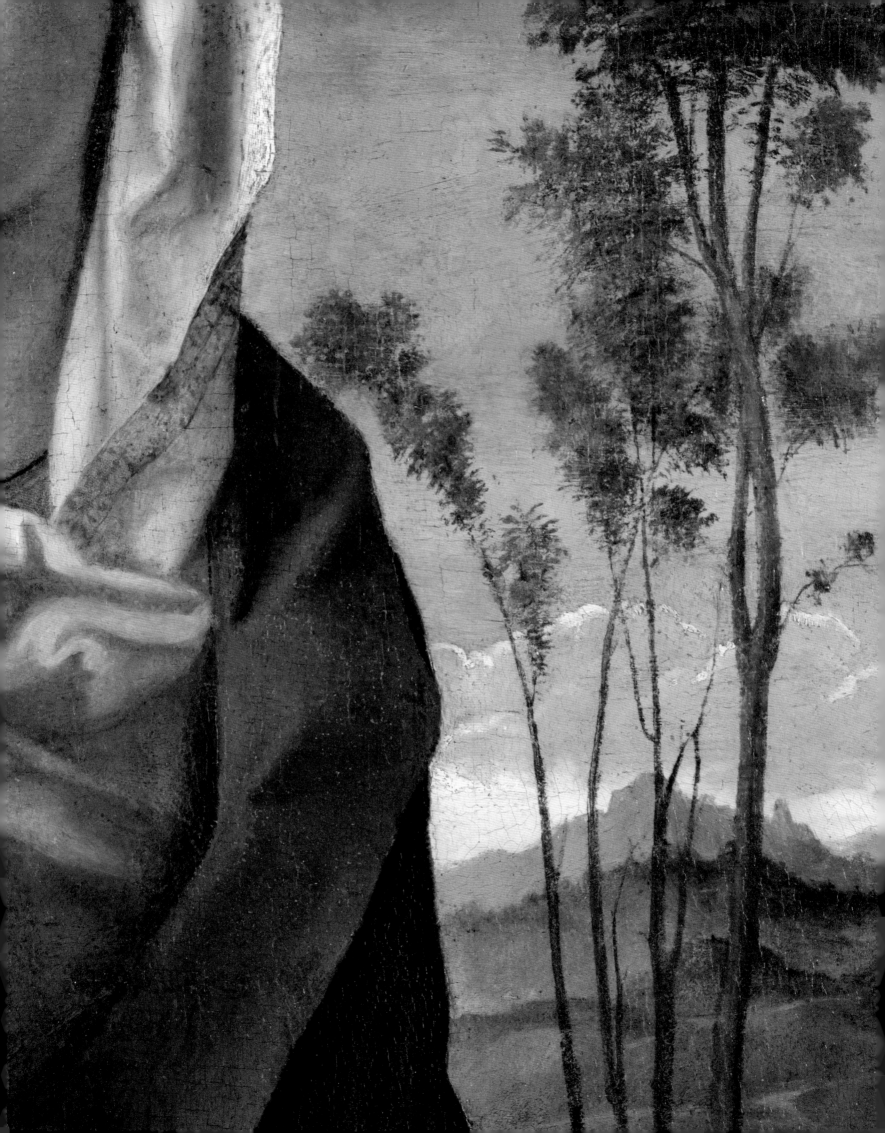

The *Madonna and Child* presented in this book was part of the well-known Dudley collection until 1892; it then passed to the Shaw-Stewart family, where it remained until 2010, when the heirs of Niel Rimington, a descendant of the Shaw-Stewart family, sold it at auction. During the entire twentieth century the painting was rarely available to the public or to art historical research, having been exhibited only in 1955 and 1957, when in some areas the painting remained quite badly overpainted.

Attributions of the work hitherto have varied from 'Giovanni Bellini' or 'Bellini and workshop' to 'pupil of Bellini'. The fact that there exist a number of contemporary copies (some of which, even though patently of lower quality, have been regarded as the autograph original), is remarkable and shows the importance which was already attributed to this composition in the sixteenth century.

Antonio Mazzotta, while serving as Curatorial Assistant at the National Gallery in London, first saw the Dudley Madonna in 2009, while it was on loan to the Fitzwilliam Museum, Cambridge, after more than fifty years of seclusion, and was profoundly impressed by it. He shows in this book that not only is it a genuine work by Giovanni Bellini himself, but that it marks a turning-point in the late work of the artist. In this period Bellini took over 'modern' forms of expression and representation not only from colleagues such as Titian and Giorgione, but also from non-Venetian painters like Raphael and Fra Bartolomeo. The prompt receptivity and response of the artist – at the peak of his fame and at the age of more than seventy-five – to new and hitherto unseen ideas, which he then introduced into his own paintings, makes Giovanni Bellini unique and, as Albrecht Dürer put it in a letter while staying in Venice in 1506, "still the best in painting".

GIOVANNI BELLINI
(Venice, *c.* 1430–1516)

The Madonna and Child (The Dudley Madonna), *c.* 1508

Oil and tempera on panel
65.8 × 48.2 cm
Signed on the parapet: · IOANNES BELLINVS ·

PROVENANCE

Bologna, private collection, until around 1826/30; London (Dudley House, Park Lane), John William Ward (1781–1833), 1st Earl of Dudley, from around 1826/30 until 1833; London (Dudley House, Park Lane), Revd William Humble Ward (1781–1835), from 1833 until 1835; London (Egyptian Hall, Piccadilly, and Dudley House, Park Lane), William Ward (1817–1885), 1st Earl of Dudley of the second creation, from 1835 until 1885; London (Dudley House, Park Lane), estate of William Ward, from 1885 until 25 June 1892; London, Christie's, 25 June 1892, lot 45 (sold for 1,150 guineas); London, Agnew's, from 25 June 1892; Fonthill Abbey (Tisbury, Wiltshire), Michael Robert Shaw-Stewart (1826–1903), 7th Baronet of Greenock and Blackhall, from after 25 June 1892 until 1903; Fonthill Abbey (Tisbury, Wiltshire), Walter Richard Shaw-Stewart (1861–1934), from 1903 until 1934; Fonthill Abbey (Tisbury, Wiltshire), Brigadier Reginald Gordon Ward Rimington (1891–1941), from 1934 until 1941; Fonthill Abbey (Tisbury, Wiltshire), Niel Rimington (1928–2009), from 1941 until 2009; Fonthill Abbey (Tisbury, Wiltshire), estate of Niel Rimington, from 2009 until 6 July 2010; London, Christie's, 6 July 2010, lot 36 (sold for £3,513,250); private collection, from 6 July 2010

EXHIBITIONS

1828, London, British Institution (no. 31) (?)
1851, London, Egyptian Hall
1852, London, Egyptian Hall
1855, London, Egyptian Hall
1871, London, Royal Academy of Arts, Burlington House (no. 315)
1894–95, London, The New Gallery (no. 111)
1955, Birmingham, City of Birmingham Museum and Art Gallery (no. 10)
1957, Manchester, City of Manchester Art Gallery (no. 58)
2008–10, Cambridge, Fitzwilliam Museum (temporary loan)

BIBLIOGRAPHY

Catalogue 1828, p. 13, no. 31; WAAGEN 1838a, II, p. 204; WAAGEN 1838b, II, p. 397; WAAGEN 1843, p. 174; MARCHESE *et al.* 1849, p. 25; H.W. 1851, p. 723; FARQUAR 1855, p. 22; CROWE AND CAVALCASELLE 1871, I, p. 190, note 8, and p. 592, note 8; *Exhibition* 1871, p. 29, no. 315; MILANESI 1878, p. 180; *Catalogue* 1892, p. 19, no. 45; *Exhibition* 1894, p. 4, no. 111; BERENSON 1895, pp. 28–29; FFOULKES 1895, p. 75; SEIDLITZ 1895, p. 211; BERENSON 1901, p. 126; BERENSON 1908, pp. 126–27; CROWE AND CAVALCASELLE (1912), I, p. 188, note 9; *Exhibition* 1955, p. 10, no. 10; WATERHOUSE 1955, p. 295; H.A. 1956, p. 45; *Art Treasures* 1957, pp. 16–17, no. 58; BERENSON 1957, I, p. 110; PALLUCCHINI 1959, pp. 106, 155, fig. 211; GIBBONS 1962a, p. 128; HEINEMANN 1962, I, pp. 20–21, no. 61e, II, fig. 571; BOTTARI 1963, pp. 31–33, no. 110, pl. 110; PIGNATTI 1969, pp. 108–09, no. 197, fig. 197; DE VECCHI 1975, p. 352, no. 25; TEMPESTINI 1976, pp. 58, 62, note 19; A.G. De Marchi, in ANGELELLI AND DE MARCHI 1991, p. 90, under no. 156; [F. Russell], in *Old Master* 2010, pp. 100–03, no. 36

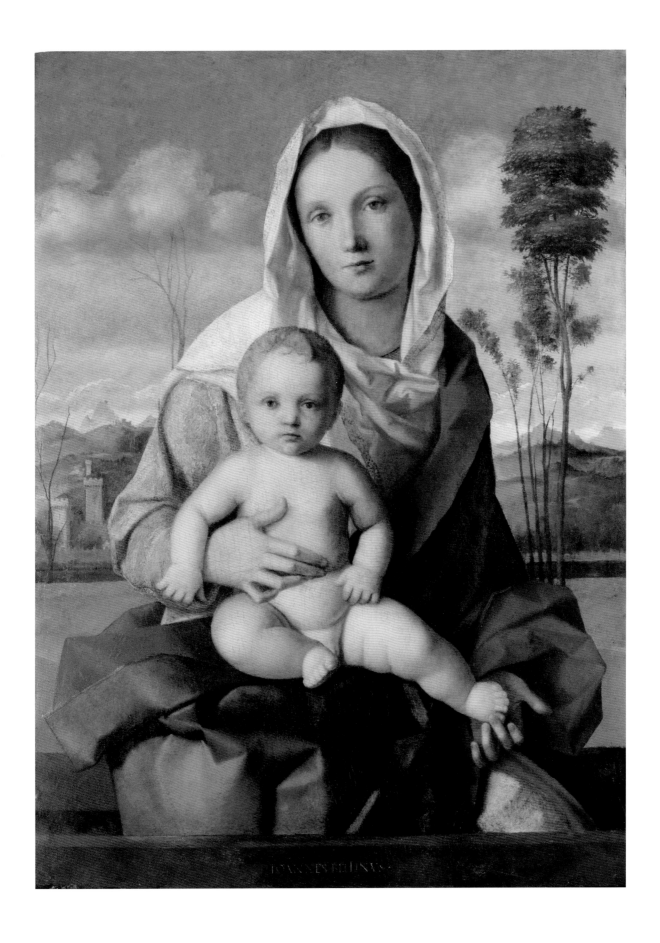

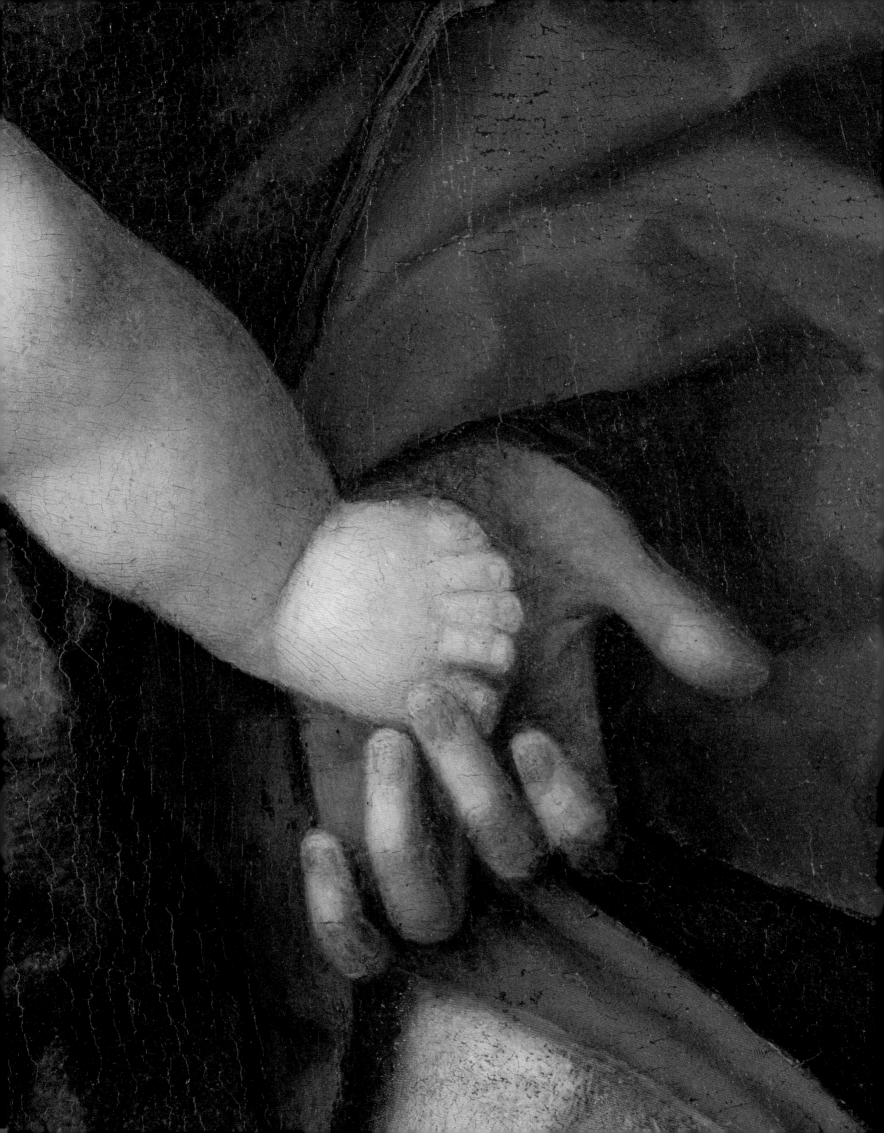

The History of a 'Modern' Madonna in Giovanni Bellini's Sprightly Old Age*

Description and Iconography

The Virgin Mary rises up like a giant Tower of Babel, in close-up, separated from us by a slender railing along which runs the painter's signature.[1] She appears to be sitting on a marble slab, slightly raised in relation to the landscape. Her right shoulder is thrust forward to show us her nude son. She steadies him with her right hand pressed against his belly, while the other hand delicately cups the little foot, without touching it. Like the Virgin, the Child looks straight at us, indifferent even to the uncontrolled diagonal thrust of his legs, which counters the opposite diagonal of the coppery lining of the mother's cloak climbing up behind him to her left shoulder. Two trees, a tall, verdant poplar on the right, and a dry, leafless one on the left, seem to have put down roots in the immense 'tower' in the foreground. All around, a succession of fields, woods, hills, mountains, towns with towers, and the sky and clouds.

All the compositional elements of figures and landscape seem to be harmonized through the use of a very subtle technique of juxtaposition, one of Giovanni Bellini's most characteristic devices, employed throughout his career. Objects painted in the foreground link visually with others in the background, enriching and emphasizing certain aspects, adding complexity to the composition as a whole. The effect is as if to generate the sense-impression of a 'false attachment'. The above-mentioned trees, for example, seem to be rooted in the Virgin's mantle. On the Virgin's right shoulder, the edge of the white veil seems to start implicitly from Christ's cheek, to continue up, and then down, making a journey through the Virgin's red robe. The outline of the coppery lining of the mother's cloak on the right ends up exactly at the angle created by Christ's leg and left arm – a subtlety that copyists never understood (see Appendix II).

* *The Madonna and Child* is also reproduced whole
on the inside back flap of the present volume

One of the most surprising aspects of the image is the dynamic way in which the mother presents her nude child – which she appears to have just finished forging. For a Renaissance artist schooled in orthodox Christianity the reason for showing the nude child would be to draw attention to the humanization of God (becoming man: in German, *Menschwerdung*; in English, 'incarnation'), to Jesus as the incarnation of God in Mary's womb.[2]

Particularly subtle is the way that Jesus's right leg covers his genitals, but only partially, allowing a glimpse. Earlier in his career, Giovanni Bellini, one of the greatest interpreters – and one of the most assiduous practitioners – of the subject of the Virgin and Child in painting, had already experimented with such a barely suggested allusion to Christ's sexuality. In the much earlier *Madonna and Child* at the Accademia Carrara in Bergamo (fig. 1), for example, it is not the child's leg half-covering his sex, but the Virgin with her cloak. It is no coincidence that the Bergamo painting is featured on the cover of one of the editions of Leo Steinberg's famous book on the subject, *The Sexuality of Christ in Renaissance Art and in Modern Oblivion*.

Saint Augustine said that the human form taken on by the Word in Mary's womb was perfect in all the parts of a man ("made up of all the members": *Civitas Dei*, XXII, 18). In the Madonna under examination, another reference to Christ's corporeal life is the parapet and the marble slab upon which Mary sits, a clear allusion to the sepulchre, and thus a reference to the Resurrection. And, in effect, the Child emanates the power of a risen Christ. Even the contrast between the small, dry tree on the left and the tall lush one to the right is not coincidental; they usually signify death and resurrection, but can also refer to the passage between the eras *ante legem* and *sub lege*, if associated with the sentence of Adam of Saint Victor: "*Synagogae flos marcescit* [withers], *et floret Ecclesia*".[3]

The real content of the painting, as in every work by Giovanni Bellini, is revealed slowly. Someone – not an art historian – who recently had the opportunity patiently to observe the work discussed here, made some notes both sensible and sensitive that I feel deserve to be mentioned:

1. Jesus ('J.')

Not a sweet baby, not playing with his mother, nearly no communication with his mother, apparently not seeking body contact with his mother ('M.')

Face and his look are not 'sweet' and lovely, but serious and demanding, and seem conscious of his commission and responsibility.

DESCRIPTION AND ICONOGRAPHY

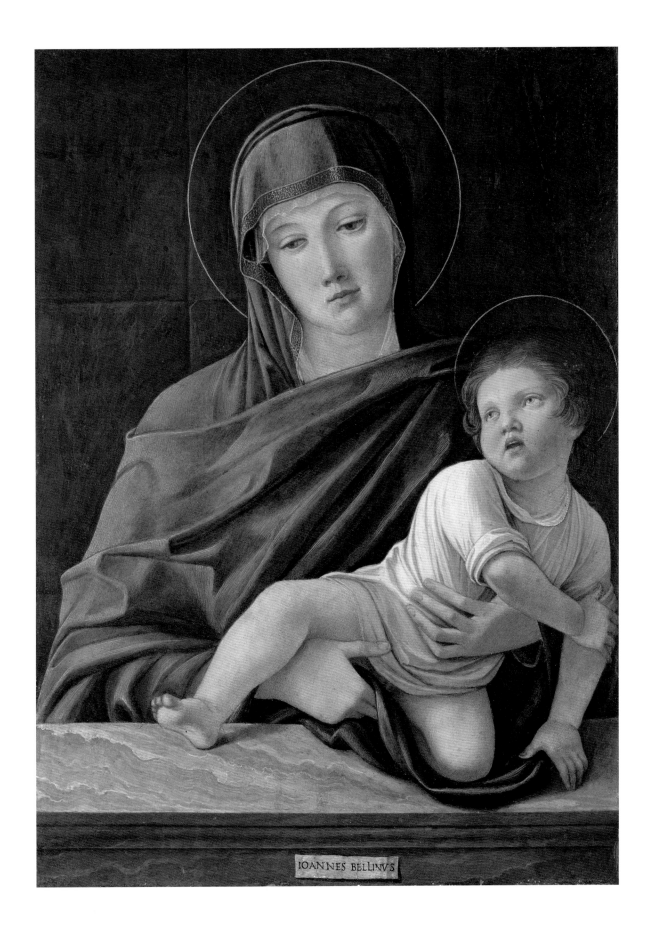

IOANNES BELLINVS

13

J. looks straight into the eyes of the spectator as if addressing him personally, telling him what tremendous tasks and sufferings are expected of J.

J. seems to be starting to step out of the painting into the area or dimension of the spectator, his left leg nearly like a runner at his starting block (which would be M.'s left hand).

M.'s right hand does not so much support J.'s chest, but seems to hold him back from leaving her in order to go out into the world.

J.'s arms are slightly bent as if he was just about to become active.

The thumb of M.'s right hand covers the spot where J. will have his wound ("... blood and water pouring out ...") when being nailed to the cross.

Even though totally naked the baby looks far from being weak or defenseless but rather offensive and prepared to fight.

2. Mary

While M. is sitting as if she were on a throne (one is looking up at her) in a pyramidal shape with landscape and clouds at her back, her head as the peak of the pyramid is stretching into the uncovered blue sky (heaven!).

Chest and left shoulder are bent backwards, thus stepping back more into the background relative to J. This is even more underlined by her right shoulder pushed forward, thus propelling J. even more into the foreground. By that means the whole painting takes on a vivid three-dimensional appearance.

M.'s head is slightly bent and at the same time turned to her right, but she looks all the same straight into the spectator's eyes. This, together with a calm, tender and sad look, evokes a spirit of resignation and acceptance of a tragic fate.

Both hands of M. are of an extraordinary delicacy and tenderness.

3. General

The light comes from the front, half left, so M.'s proper left shoulder (which is drawn backwards) and the side of her brown-blue cape are in shadow. The shadow also spreads over the proper left side of the head and the body of J., but to a lesser degree since J. is sitting frontally.

The sky shows Bellini's typical formal scheme. Directly behind the blue mountains at the horizon there is a tape of light separated from the clouds above in a rather straight line.

All of these qualities of thought and religious content, along with as many visual felicities, still emerge fully, despite the less than perfect state of preservation (see technical images in Appendix I). I will argue that this is a masterpiece by Giovanni Bellini, but, in order to establish this assertion, and the reason why this is the first time that the painting has been so fully discussed, its history should be traced – both its collecting history and its critical fortune – in order to understand the influences shaping its previous reception.

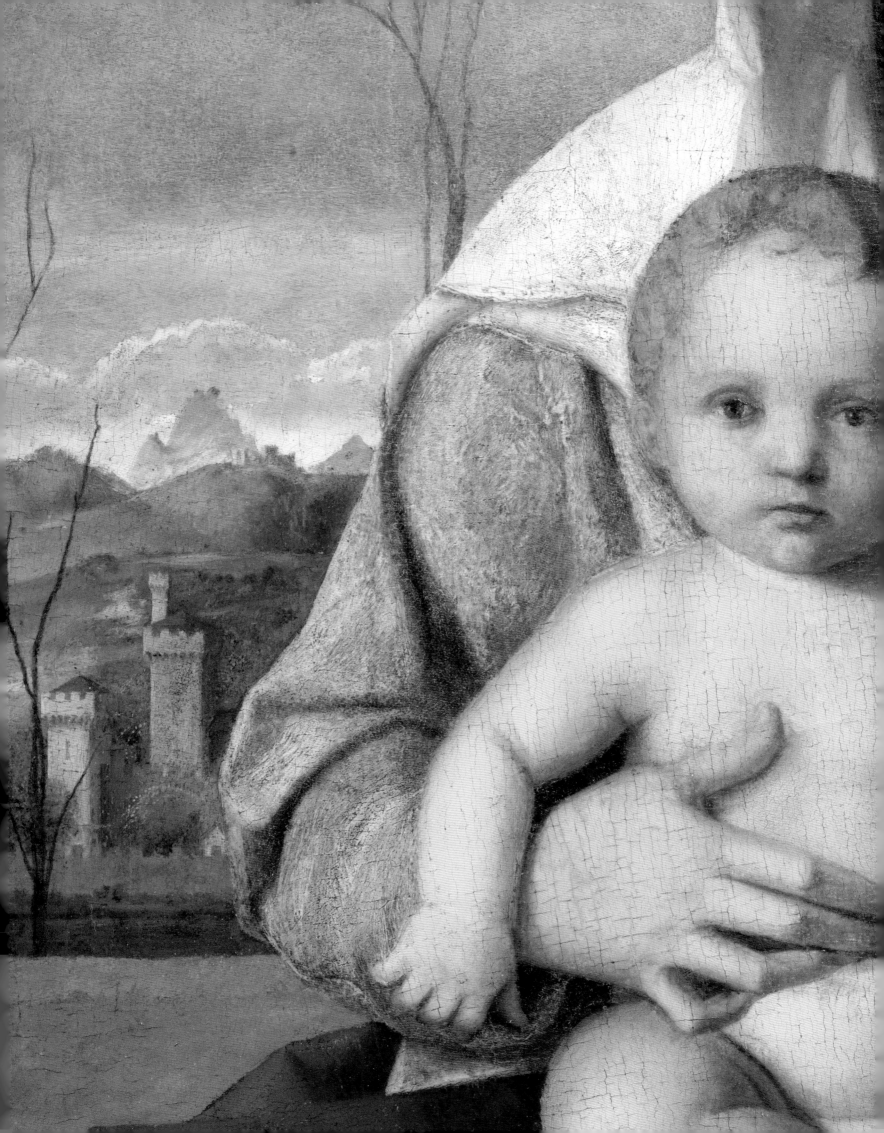

Collecting History and Critical Fortune

The history of the painting's reception is worth considering in detail. The various phases of its critical history will help us understand why such a masterpiece, which in other circumstances would have been regarded as an essential reference-point in a survey of the artist's career, has remained on the sidelines and rarely been appreciated at its true value. However, it must once have been a celebrated work, as the many copies (see Appendix II) made of it through the centuries prove. In fact, this work is among the most copied of Bellini's Madonnas.

IN THE NINETEENTH CENTURY: FROM BOLOGNA TO LONDON

An early nineteenth-century engraving by Luigi Martelli (fig. 2) replicates the composition of the *Madonna*.[4] As we shall see, Martelli's print is undoubtedly based on the version discussed here, and not on one of its many copies (see also Appendix II). The print follows the original faithfully in general, but not in every detail. The main reason for the divergences becomes clear in the light of the painting's appearance before the late 1950s, as recorded in a photograph taken at that time (fig. 3; see also Appendix I, fig. III): here the painting, still 'clogged' by overpainting, which was only subsequently removed (see Appendix I, figs. I–II), is much closer to the engraving. Martelli's engraving, for example, shows the dry tree on the left lush with foliage, as in the 1950s photograph. The overpainting must therefore have occurred before his engraving was made, in the early nineteenth century. Only one painted copy (Appendix II, copy E) shows similar foliage, but the print was clearly not copied after this painting. Another important particular in which the print differs from the original is that Christ's sex is covered by a piece of drapery: in this case it is not clear whether that was Martelli's own prudish decision, or reproduced another area of overpaint.

2
LUIGI MARTELLI
(after Giovanni Bellini)
The Madonna and Child,
c. 1826–30
Reggio Emilia, Biblioteca Panizzi,
Raccolta Davoli, inv. no. 9124

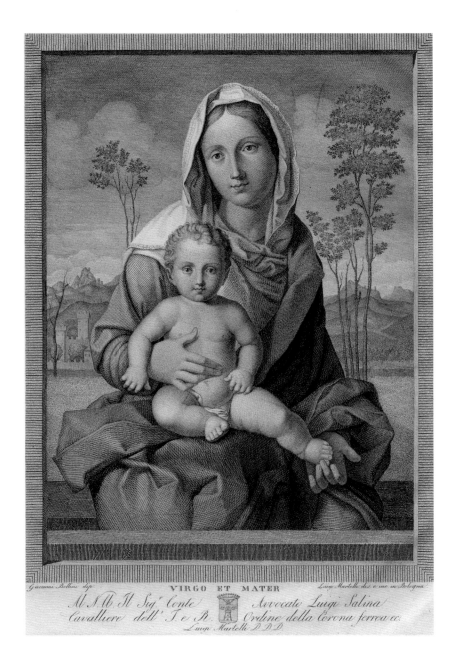

Martelli's engraving bears several inscriptions at the bottom that provide us with some interesting information, although none of them reveals the ownership of the painting. Immediately below the fictive perspectival frame, we read "*Giovanni Bellini dip.*" [painted] and "*Luigi Martelli dis. e inc.* [drew and engraved] *in Bologna*", and in the middle "*VIRGO ET MATER*". Below is a dedication, "*Al N.M. Il Sig. Conte Avvocato Luigi Salina / Cavalliere dell'I. e R. Ordine della Corona ferrea / Luigi Martelli D.D.D.*". If we can therefore assume that Martelli executed the print in Bologna, that is evidence of the picture's early nineteenth-century Bolognese provenance, before it entered the Dudley ownership from which it takes its

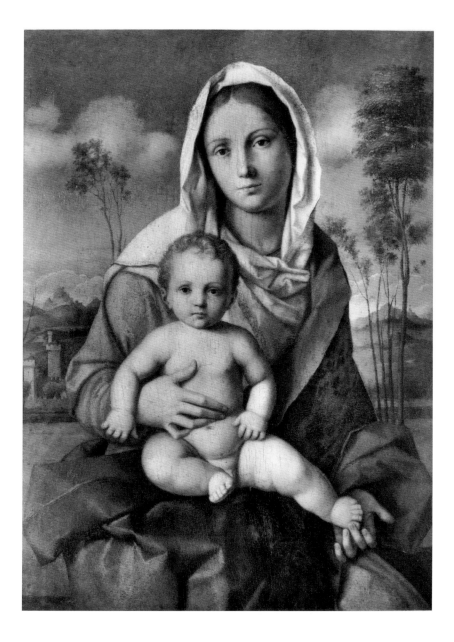

name. The dedication to Luigi Salina confirms but does not indicate any more precise location for the picture.[5]

Having begun his career in Bologna in the mid 1820s, Luigi Martelli undertook work for Conte Salina in 1830, making an engraving of the portal of Salina's palace, Palazzo Salina Amorini Bolognini, which appeared in a pamphlet by Gaetano Giordani.[6] It was probably in the years preceding 1830 that Martelli executed the engraving after Bellini's Madonna and dedicated it to Salina.[7]

When or how the painting reached Bologna is not documented, nor how it came from Bologna to England, but it is very likely that the painting was acquired in Bologna by John William Ward, who in 1827 became the

4

1st Earl of Dudley. He was described by his contemporaries as a cultured, educated man, with many talents, but also, especially in his later years, tending to madness.[8]

Ward was a great traveller, and it is not unlikely that he had seen (before he later decided to purchase) the Madonna during one of his journeys to the Continent, journeys which took place in 1814-15, in 1817 and in 1821-22. Indeed in a letter written in 1814, while in Italy, he asserted that in Bologna "the public collections are not by any means of first-rate value, but there are a great many very fine pictures in the hands of private persons".[9] Ward was in Venice in the summer of 1815, and again in the autumn of 1817, where he probably met up with his friend Lord Byron, and it is reasonable to assume that it was at this time that he became familiar with Giovanni Bellini's work in the city.[10]

It was also in 1815 that the physician Francesco Aglietti published in Venice his *Elogio storico di Jacopo e Giovanni Bellini*, based on a lecture he had presented three years earlier at the Accademia di Belle Arti of Venice. This work was highly influential, for it offered a profound and pioneering insight into the late activity of Giovanni Bellini.[11] At one point Aglietti refers to a work which – as we shall see – is stylistically very close to the one under examination: "The beautiful panel of the Virgin seated in the midst of a lovely landscape in the Mocenigo palace at San Polo, inscribed with the year 1509". This *Madonna and Child* is today in the Detroit Institute of Arts (fig. 48).[12]

Unfortunately we know little about the provenance of the works that John William Ward had begun to gather at the residence he built on Park Lane in London later known as Dudley House.[13] In 1828 he lent a Madonna attributed to "Jan de Bellini", together with a Bellini assumed to be a self-portrait, to an exhibition at the British Institution in London.[14] But we cannot be certain that this was our Madonna, which may still have been in Bologna.[15] In 1831 Johann David Passavant visited the Dudley collection and two years later published his impressions of two famous paintings, Raphael's *Three Graces* (today at the Musée Condé, Chantilly, inv. no. PE 38) and *The Mass of Saint Giles* (National Gallery, London, inv. no. NG 4681), a masterpiece believed at the time to be by Jan van Eyck (or his school), but today ascribed to an artist known as the Master of Saint Giles; but he does not mention the Bellini.[16]

Upon his death in 1833, Ward left no direct heirs, and the barony (but not the title of Earl of Dudley, which lapsed) and his estate passed to his contemporary and second cousin the Reverend William Humble Ward. He in turn died soon afterwards, in 1835, leaving an heir, his very young son William Ward, who in his youth would be noted as a squanderer of fortunes.[17]

In 1835 the collection was visited by the great German connoisseur (and director of the Gemäldegalerie des Königlichen Museums in Berlin) Gustav Friedrich Waagen, his curiosity certainly piqued by Passavant, as he remarked in his *Works of Art and Artists in England* (1838): "In the very mixed collection of the late Lord Dudley, I looked in vain for the Three Graces, by Raphael, which Passavant saw there, but found some other pictures worthy of notice".[18] Waagen, however, provided both the earliest description of what is indisputably our Madonna and an apt and discerning appreciation of its quality: "Giovanni Bellini. The Virgin and Child in a landscape, has not only his calmness and composure in the religious feeling, but is of remarkable clearness in the colouring, and unusual elegance in the hands of Mary. It bears the name of the artist."[19] This passage is followed by one describing a *Madonna and Child* by Francesco Francia, identifiable with the fine Madonna held today at the Yale University Art Gallery in New Haven, known as the Gambaro Madonna (fig. 4).[20] Since this Madonna by Francia almost certainly came from Bologna, it is very likely that this and the Bellini Madonna were bought there together, and at the same time.[21]

Over the next two decades, the young Ward mended his ways and began to add many important new works to the collection: in 1847, he was in Rome, and in one fell swoop bought 60 paintings from conte Guido di Bisenzo, including Carlo Crivelli's *Pietà* today at the Metropolitan Museum, New York (inv. no. 13.178), and several masterpieces formerly belonging to Cardinal Fesch, Napoleon's uncle – among them Raphael's Mond Crucifixion today in the National Gallery in London (fig. 5).[22] Thus to Ward goes the credit for bringing his distant relative's collection to the level of international prominence. In the Le Monnier edition of Vasari's *Lives* of 1849, the commentary to the 'Life' of Giovanni Bellini reads (with a wink and a nod to Waagen): "Leaving Italy and making for other lands, we should first mention Giovanni's pictures that are now in England. Lord Budley's [*sic*] collection holds a Madonna and Child, signed with the painter's name. It is a work that enhances the sweetness and peace of religious feeling with a particular transparency of colour and a rare beauty in the Virgin's hands. Mr Beckford's picture gallery holds the portrait of the Doge Vendramin in profile, signed with the name of Giovanni and the year, which, although the picture is placed very high up, seems to be 1476. Like the portrait of another Doge, seen full-face, with the inscription: *IOANNES BELLINVS*."[23]

This last painting is, of course, the London National Gallery's *Doge Leonardo Loredan* (inv. no. NG 189). The casual association of the Ward Bellini with Beckford's is intriguing not only because John William Ward, the first English owner of the Dudley Madonna, was a friend of

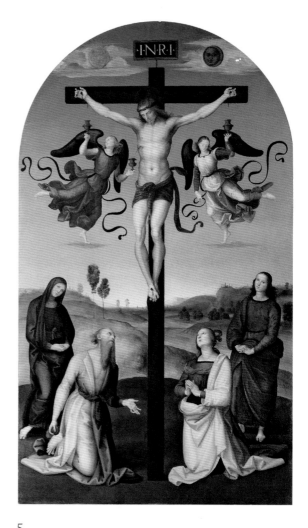

5
RAPHAEL
Christ on the Cross (The Mond Crucifixion), *c.* 1502–03
London, The National Gallery, inv. no. NG 3943

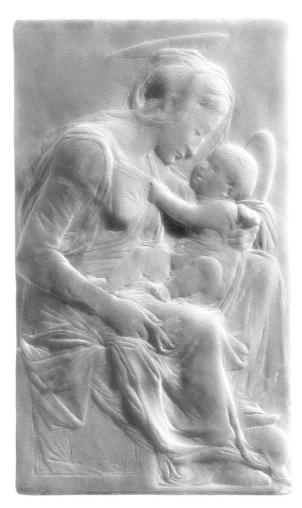

6
DONATELLO
The Madonna and Child (The Del
Pugliese-Dudley Madonna),
c. 1440
London, Victoria and Albert
Museum, inv. no. A.84-1927

William Beckford, but also because in the Beckford collection it was kept at Fonthill Abbey, a location to which we shall have occasion to return.[24]

In 1851, Ward took advantage of substantial renovation work in his Park Lane house to show his by now magnificent collection off to the public at the Egyptian Hall in Piccadilly. In one year, some 50,000 art lovers, including many European connoisseurs, visited the exhibition; at that time Early Renaissance art was perhaps better represented there than at the National Gallery.[25] Its success (and failure to finish work in the Park Lane house) led to an extension of the show – with free entry six days a week – in 1852 and again in 1855. In 1860, Ward was created Earl of Dudley, receiving John William Ward's lapsed title, and from this time on the collection became known as the Dudley Gallery. It also included major sculptures, such as a masterpiece by Donatello, a marble relief of the Virgin and Child, also known as the 'Del Pugliese-Dudley Madonna' (fig. 6). Today in the Victoria and Albert Museum, it is there masochistically displayed with the attribution 'Style of Desiderio da Settignano', alongside seventeenth-century beer mugs in a showcase entitled 'Virtuoso Carving'.[26]

At the same period, Giovanni Battista Cavalcaselle, the founding father of modern connoisseurship, was in London. As his travel diaries and loose pages conserved at the Biblioteca Marciana in Venice suggest, he visited the Dudley collection several times. Bellini's Dudley Madonna appears twice among the sketches he habitually made to capture compositions and record colours. In the first of these (fig. 7), the visual note is part of a series recording pictures in the Dudley collection during a visit made between 1851 and 1852 (probably when it was displayed at the Egyptian Hall) together with Charles Lock Eastlake, then President of the Royal Academy and from 1855 Director of the National Gallery.[27]

Alongside the pencil drawing recalling the composition, the essence of which Cavalcaselle captures with a few strokes, also indicating the main colours, white, azure and yellow, is written (in Italian): "Without the label, I would have taken it to be a painting from the School of the Bellini". Just below: "nice landscape". Then: "If the signature is antique it is copied". Beneath the sketch: "marked on the stone IOANNES BELLINVS". "Name suspicious, or copy of the third Bellini? See Vasari."[28]

The second sketch (fig. 8) dates, with certainty, to 1865, appearing on one of the sheets related to Cavalcaselle's return visit to the Dudley collection in that year.[29] The composition is more tersely indicated than the first time, though the colour scheme is described in more detail. Beneath the sketch, a series of notes: "Reddish IOANNES BELLINVS / Panel by Bellini / Since that name was added, / covering or retouching an antique signature, / it was made by a copyist copying a / bellini – a painting with

7
GIOVANNI BATTISTA
CAVALCASELLE
Sketches after some Dudley
pictures, *c.* 1851–52
Venice, Biblioteca Marciana,
Fondo Cavalcaselle, It. IV. 2037
(=12278), Taccuino VII, f. 9v

8
GIOVANNI BATTISTA
CAVALCASELLE
Sketches after some Dudley
pictures, 1865
Venice, Biblioteca Marciana,
Fondo Cavalcaselle, It. V. 2033
(=12274), Fascicolo XX, f. 54v

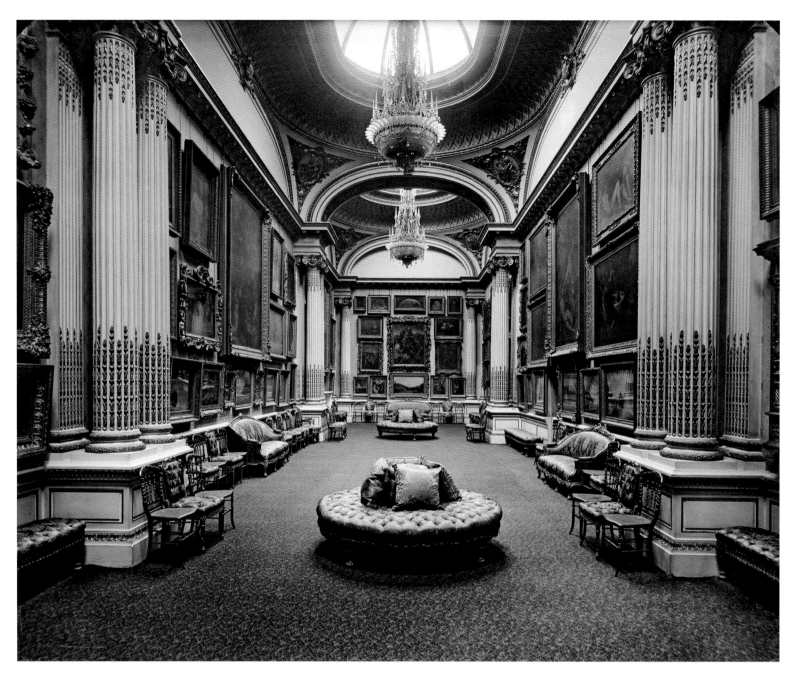

9
ANONYMOUS
Dudley House Picture Gallery,
at Park Lane, 1890
London, English Heritage,
National Monuments Record,
neg. no. BL10315

an appearance that is more / modern – lovely old copy / <u>lovely picture</u> – a nice but from the school / in the style of <u>Bissolo</u> but more solid / (more empty than some of Rondinelli's paintings / in the manner of B)".[30]

Cavalcaselle's somewhat ungenerous evaluation stemmed from his ignorance of the elderly Bellini's real artistic physiognomy.

Cavalcaselle's travel diaries and notes formed the basis of *The History of Painting in North Italy*, written together with Joseph Archer Crowe and published in 1871 in two volumes. Here we may read of the Dudley Madonna: "Lond., Dudley House, Virgin and child, in a landscape, inscribed: 'Joannes Bellinus' (wood, half-length), by a freehanded follower of Bellini, such as Rondinello shows himself", and a few pages on: "reminiscent of Rondinello at the School of Bellini".[31] Niccolò Rondinelli was a modest pupil of Bellini's, active in and around Ravenna at the start of the sixteenth century. It is enough to take any of his signed Madonnas, for example the very modest one in Galleria Doria Pamphili in Rome (inv. no. 126), to see the unviability of the proposed attribution. Let us not forget, however, that at that time the painting was marred by overpainting, still quite evident in a photograph of *c.* 1955 (see fig. 3, and Appendix I, fig. III), which had altered its appearance, excessively softening the facial features and expressions.

The Madonna was shown again in 1871 along with another 127 paintings from the Dudley collection in Burlington House Gallery VI, in the Royal Academy of Arts.[32] The size and splendour of the Dudley collection at its peak can be surmised from photographs of the Dudley House Picture Gallery, which date from July 1890, five years after William Ward's death.[33] In one of these (fig. 9), on the back wall (fig. 10), our Madonna can be glimpsed (the second painting from the right in the lowest row), surrounded by works of later date: to the right, a still life; to the left, a *veduta* of Venice (perhaps a Canaletto); further to the left, a *Madonna and Child* by Francia, today held by the National Trust at Wallington Hall, Cambo, Northumberland (inv. no. P/8).[34] Further up, in the centre of the wall, a copy of Andrea del Sarto's *Madonna of the Steps* (Madrid, Museo del Prado, inv. no. P00334) and to the left a copy of Raphael's *Madonna del Cardellino* (fig. 38).[35] The photograph also provides us with further certainty that our Madonna, protected by glass, by this date was already showing the retouchings (the tree on the left already has the added leaves) that altered its appearance until a few decades ago (see Appendix I).[36]

On 5 June 1892 much of the Dudley collection went to auction at Christie's in London. The Dudley Madonna appears under lot 45 and was sold to Agnew (acting for Sir Michael Robert Shaw-Stewart) for the significant price of 1,155 guineas.[37] To get an idea of its relative value at the time, the above-mentioned Mond Crucifixion by Raphael (fig. 5) and Crivelli's *Pietà* were sold for 11,130 and 346 guineas respectively.

10
ANONYMOUS
Dudley House Picture Gallery, at Park Lane, detail of fig. 9

Art history and the scope of collecting were in rapid transformation in London in these decades: the period of big exhibitions on the Italian painting schools had begun. In 1894–95 the New Gallery hosted an *Exhibition of Venetian Art* decisive for the critical fortune of many Venetian paintings on display there, including our Madonna (no. 111 in the catalogue), loaned by Shaw-Stewart. Shaw-Stewart in the meantime had assembled a considerable number of Venetian paintings, including the *Madonna and Child* presently at the Metropolitan Museum in New York (fig. 25), also on show at the New Gallery (no. 146), which we shall discuss shortly.

Bernard Berenson was shooting to success with the publication in 1894 of his revolutionary 'lists' of *The Venetian Painters*, followed in 1895 by the equally revolutionary monograph *Lorenzo Lotto: An Essay in Constructive Art Criticism*. He was amongst the visitors to the New Gallery show, and wrote a lengthy review in the form of a pamphlet entitled *Venetian Painting, Chiefly before Titian, at the Exhibition of Venetian Art. The New Gallery, 1895*. This publication (like the lists) had an enormous influence among scholars of Venetian art, both at the time and in later generations.[38] Berenson tried to bring order to his subject by creating various stylistic groupings, and in the process de-attributed several works, especially (and often correctly) from Giovanni Bellini's oeuvre. His wrecking-ball approach to Bellini's catalogue – in particular of the later work, at the time still nebulous – is confirmed by his own words: "Indeed, were we to trust all existing catalogues, the number of his pictures would be legion! ... a proportion of about one to six being the usual ratio of genuine Bellinis to merely attributed pictures!".[39] Berenson was to adopt a similar wrecking-ball policy with respect to Sandro Botticelli's catalogue, also creating the famous and phantasmagorical 'Amico di Sandro', who took over a number of works that nowadays are considered to be either by Botticelli himself or by Filippino Lippi in his most Botticellian phase.[40]

This process of attributional shifts also involved our Madonna, and to achieve a full understanding of Berenson's ideas about it, ideas that unmistakably had an influence in the history of art criticism in the course of the twentieth century, it is worth citing the entire paragraph, in which he groups under the name of the Bergamasque painter Rocco Marconi a number of the works displayed at the New Gallery under that of Giovanni Bellini:

"Suggestive of Bissolo in sentiment and colour, but altogether superior in character, are three pictures in this exhibition, all ascribed to Bellini, and all of them, if I mistake not, by the same hand. The *Virgin and Child*

(No. 111, signed IOANNES BELLINVS [the Dudley Madonna]), belonging to Sir Michael Shaw-Stewart, is a charming panel of delicate sentiment, and refined, very blonde amber colouring. The same colouring and the same style of landscape reappear in one of the most delightful portraits of the Venetian school (No. 149, belonging to Mr. J.P. Carrington [fig. 13]), – the bust of an alert, self-possessed, sympathetic youngish man, with bushy brown hair, wearing a black cap and a black coat slashed with white – in conception not unworthy of Bellini himself, although widely different from him. In Lord Northbrook's *Madonna* (No. 19, signed IOANNES BELLINVS [fig. 12]), with its exquisite landscape, we find the same delicacy of sentiment, and the same beautiful ambered lights. 'A replica of the central group of a picture in the Redentore at Venice,' says the catalogue. Quite so: the compositions are identical, but the execution is not. In this respect, as well as in the blondness of the hair, in the slight difference of axis to the eyes, and in the landscape, Lord Northbrook's *Madonna* stands much closer to a *Madonna* identical in composition, in the Strasbourg Gallery (No. 8, photographed by Mathias Gerschel, Strasbourg [fig. 11]), signed ROCVS DE MARCHONIB. It is to this hitherto little known painter, Rocco Marconi, that I venture to ascribe the three pictures we have been discussing. Thus far he has passed as a mere imitator of Palma and Paris Bordone, and in his later years he, doubtless, deserved this bad reputation. In the Strasbourg *Madonna*, however, we see him starting from Bellini, but with a tendency of his own towards a very blond colouring – a tendency which we find amply developed in his masterpiece, *The Lamentation* of the Gallerie dell'Accademia, Venice (Sala VII, No. 30 [fig. 53]). Delicate and refined as is Mr. Carrington's portrait, the faces of the dead Christ and of the Virgin will bear comparison with it; and as to its greater spirit, this would not be the first instance of a painter surpassing his usual self in portraiture (cf. Cordeliaghi and Girolamo Santacroce in their portraits in the Poldi-Pezzoli Museum at Milan). A further confirmation of my hypothesis may be found in still another work exhibited here. It is the full-length figure of the *Saviour*, ascribed to Cima (No. 23, lent by Mr. Charles Butler). Although the figure certainly is copied from Cima's *Saviour* at Dresden, the execution and the landscape clearly betray Marconi's hand, as we know it in his pictures at Venice – not only the *Deposition* already mentioned, but the works in San Cassiano and San Giovanni e Paolo as well. Now careful scrutiny reveals more than one point of likeness between this *Saviour* and the three other pictures I have ventured to ascribe to Rocco Marconi. Nor are these the only pictures in London in which I recognise the same hand, presumably that of Rocco. Others are the pretty landscape, called a Giorgione, belonging to Lord Ashburnham (now on exhibition at the 'Old Masters,' in Burlington

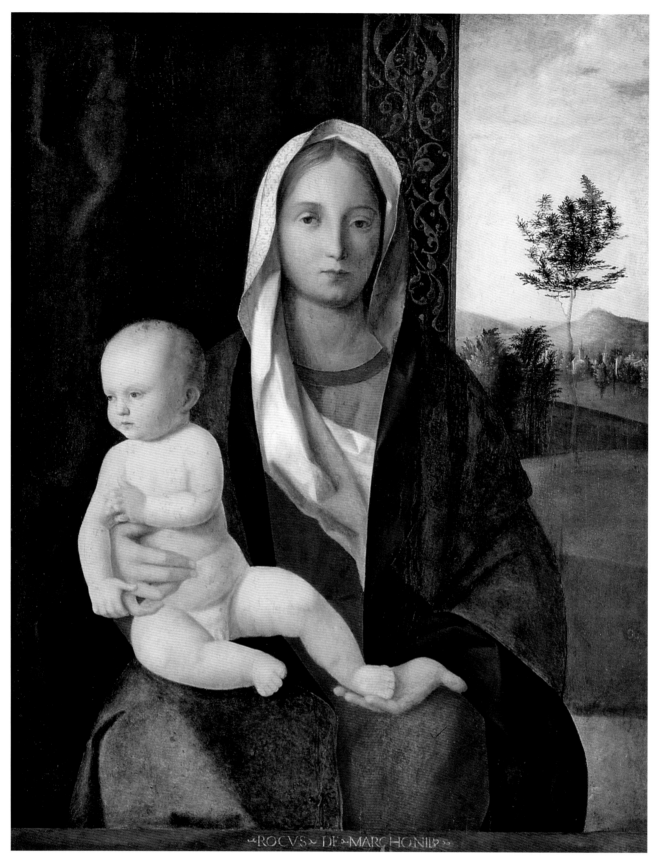

11
ROCCO MARCONI
The Madonna and Child, c. 1505
Strasbourg, Musée des Beaux-
Arts, inv. no. 174

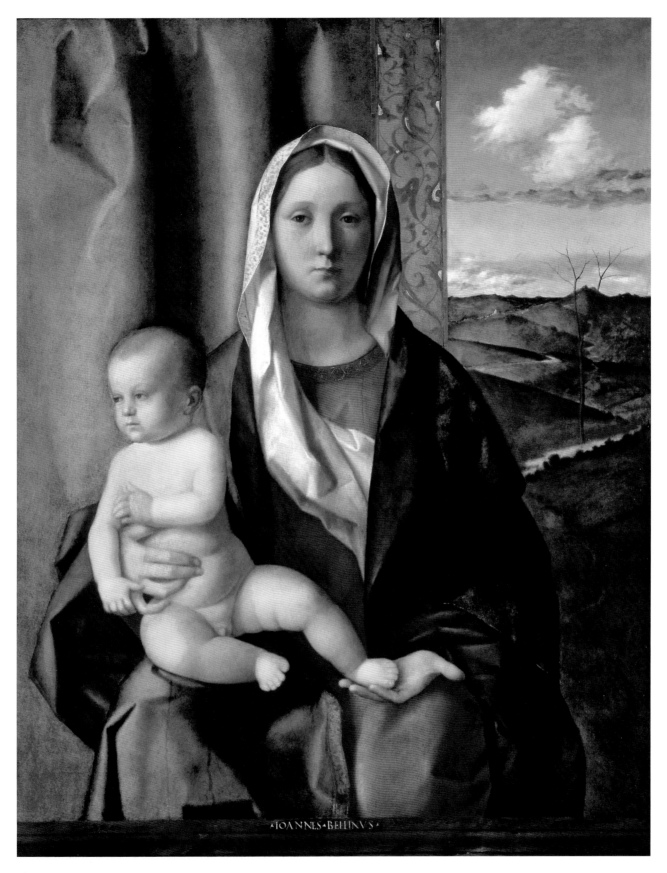

12
GIOVANNI BELLINI
AND WORKSHOP
The Madonna and Child (The
Northbrook Madonna), *c.* 1500
Atlanta, High Museum of Art,
inv. no. 58.33

House, No. 115), containing in the foreground two men fencing and another piping; and, finally, the picture in the National Gallery, representing the *Death of St. Peter Martyr* (No. 1252 [fig. 31]), signed *Ioannes Bellinus*, and executed in his *atelier*".[41]

Berenson tosses out quite a few ideas here. The two points of departure for this group of additions to Rocco Marconi's youthful oeuvre would thus be:

1. The Gallerie dell'Accademia's *Lamentation* (fig. 53), formerly in the church of the Servi in Venice and attributed to Marconi by relatively early sources (Marco Boschini in *Ricche minere*, 1674, and Antonio Maria Zanetti in *Della pittura*, 1771), and for this reason believed by Berenson to be definitely the work (if not the youthful masterpiece) of the painter from Bergamo.

2. The *Madonna and Child* signed ROCVS DE MARCHONIB[VS] in the Strasbourg Musée des Beaux-Arts (fig. 11).

These two 'certain' works also swept along with them into Marconi's catalogue our Madonna, 'Lord Northbrook's *Madonna*', today in the Atlanta High Museum of Art (fig. 12); the *Portrait of a Man* formerly belonging to Carrington, today in the Norton Simon Museum in Pasadena (fig. 13) as 'Attributed to Vittore Carpaccio' (we shall see that this attribution is not correct); and the *Standing Christ* today in the National Gallery of Ottawa (inv. no. 328), where it is attributed generically to the school of Bellini.[42] To this compact group Berenson then added another two works, in one of which in particular we are interested, brought into play (as we shall see, correctly) because of the similar morphology of the landscape – *The Assassination of Saint Peter Martyr* in the National Gallery, London (figs. 31–32).

Of this entire grouping, the only work that is of certain – because signed – attribution to Rocco Marconi is the Strasbourg Madonna (fig. 11). Marconi, documented in Venice from 1504, clearly demonstrates that he was aware of the solutions achieved by Bellini at the start of the sixteenth century, before converting (with not very inspiring results) to the 'modern manner' by way of Titian and Palma il Vecchio especially. Together with the Atlanta Madonna (fig. 12), which is higher in quality, particularly in terms of the landscape, the Strasbourg painting reflects an idea of the old master, simplifying it. The idea (it must be admitted, rather a bold one) is that of a Child distracted by something external to the space of the painting, making him turn his whole figure and left arm in that direction. Such a solution had already been tried by painters in Leonardo's milieu, such as Giovanni Antonio Boltraffio or Andrea Solario in the mid 1490s. The execution of the Strasbourg Madonna is no more than passable (it is much better in the Atlanta painting), and the original message

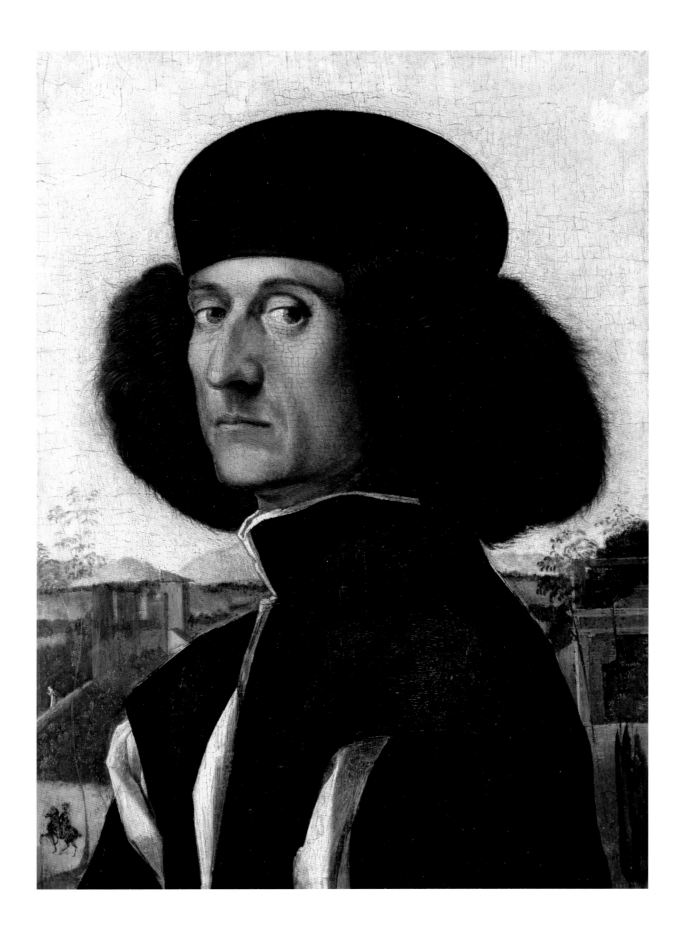

of the artist, which in his inventive variations on his favourite theme of the Virgin and Child is always so dense with meaning, here seems filtered; the sensation is that it reaches us second- or third-hand. My feeling is that both of these Madonnas can be referred to the same category of 'final examinations' in the workshop. How, then, can they possibly be associated (especially the weak and tentative one signed by Marconi) with the Dudley Madonna, so much more powerful, direct and immediate, as well as richer in pictorial effects? And how dare anyone even think that the same artist is responsible for an insignificant work like the Strasbourg *Madonna* and at the same time the grandiose Accademia *Lamentation* (fig. 53), recently returned with compelling arguments to Giovanni Bellini himself by Luciano Bellosi? This distortion of Rocco Marconi's artistic physiognomy led to his association, for example, with the Brera Madonna (fig. 50), dated 1510, again on the basis of a comparison with the signed painting in Strasbourg (quite unsustainably) and perhaps (and this time, correctly!) of the Brera Madonna's close resemblance to the *Lamentation* and to the Dudley Madonna, also considered at the time the work of Marconi.[43]

In any case, credit goes to Berenson for having grouped together works that, in effect, show similarities to one another, in some cases in terms of style (in the *Lamentation* and our Madonna), but above all in terms of their artistic and cultural background.

Before finally presenting our personal opinion about the work, however, we must continue with our survey of criticism of it over the decades in order to understand what motivated it and to identify the reasons behind the reputation of our painting.

THE TWENTIETH-CENTURY CRITICAL HISTORY; THE COPIES IN THE LIMELIGHT

Shaw-Stewart, having amassed a considerable collection of paintings, installed them at Fonthill Abbey, Wiltshire, until 1822 the residence of William Beckford, whom we already know as a friend of Lord Dudley and as the owner of Bellini's *Doge Loredan*. Shaw-Stewart had even acquired from Beckford a few paintings, such as the above-mentioned *Madonna and Child* today in the Metropolitan (fig. 25). This small and dazzling panel is of interest because it shows similarities, as already noted, with our painting – compositionally (the group with the Virgin and Child sitting on her knees seen very close up against the backdrop of a landscape); in the details (the Virgin's right hand is identical); in the iconography (the trees, one dead and the other live, that 'grow' out of the Virgin's cloak).

These similarities between the two paintings become all the more interesting when we learn that for a few decades they were kept under the same roof, to be separated in 1927.[44]

Our Madonna, meanwhile, remaining throughout the twentieth century tucked away in Wiltshire, saw her fame ebb away little by little. Almost completely forgotten by scholars, she resurfaced – and only briefly – at the 1955 Birmingham exhibition, and then again in Manchester in 1957.

Thus, the art historical trail that we must follow is one of the evaluation (often very acute) of the various copies and versions of this Madonna. It was a composition that evidently impressed Bellini's followers and the copyists of later generations – perhaps encouraged by art lovers who had seen and admired the original and, unable to possess it, longed for at least a faint trace of it.

The reader will have noticed that it is being taken for granted that our painting is the original version: this may seem somewhat overconfident, but, besides its obvious qualitative superiority to any other copy or version (see Appendix II), there are incontrovertible facts that establish the present Madonna as the prototype, which even someone sceptical of formal analysis must bear in mind. It is worth briefly introducing them now, in order to avoid doubts arising in the course of the following analysis. Clear proof is given by the infrared image (see Appendix I, fig. VI), which reveals the drawing beneath the layer of paint. In it there are obvious *pentimenti*, for example in the Child's face (fig. 14), where the position of the right eye has shifted, or in the Virgin's face (fig. 15), where instead one can see a variation in the left eye (and perhaps the right one as well), with a shift in the orientation of the gaze or in the hand brushing the foot (fig. 16) –an area rich in *pentimenti*. This is not to mention the long underdrawing lines, so free and shapely, of the Virgin's cloak (see Appendix I, fig. VI). All these phenomena are unthinkable in a copy. Only the prototype of a composition could occasion these changes in the work in progress, so subtle, yet at the same time so substantial. Any debate on the attribution of this composition must acknowledge that the prototype, the original or primary version, is beyond any reasonable doubt the one discussed here.

Setting aside for a moment the original version, we find that Guido Cantalamessa published in 1907, at Corrado Ricci's suggestion, a *Madonna and Child* then kept in the sacristy (today it is in the Sala Capitolare) of the Basilica of Santa Maria in Trastevere in Rome (Appendix II, copy A). Commenting enthusiastically, Cantalamessa attributed the painting to Benedetto Diana, since he found in it his typical "so well-calculated flow of the drapery: he has a great passion for moving the folds elegantly and

14
GIOVANNI BELLINI
The Madonna and Child
(The Dudley Madonna),
detail, infrared image
(before 2012 retouching)

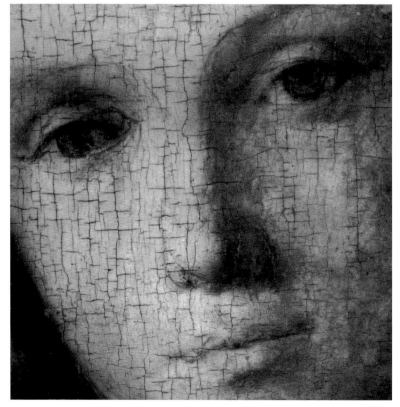

15
GIOVANNI BELLINI
The Madonna and Child
(The Dudley Madonna),
detail, infrared image
(before 2012 retouching)

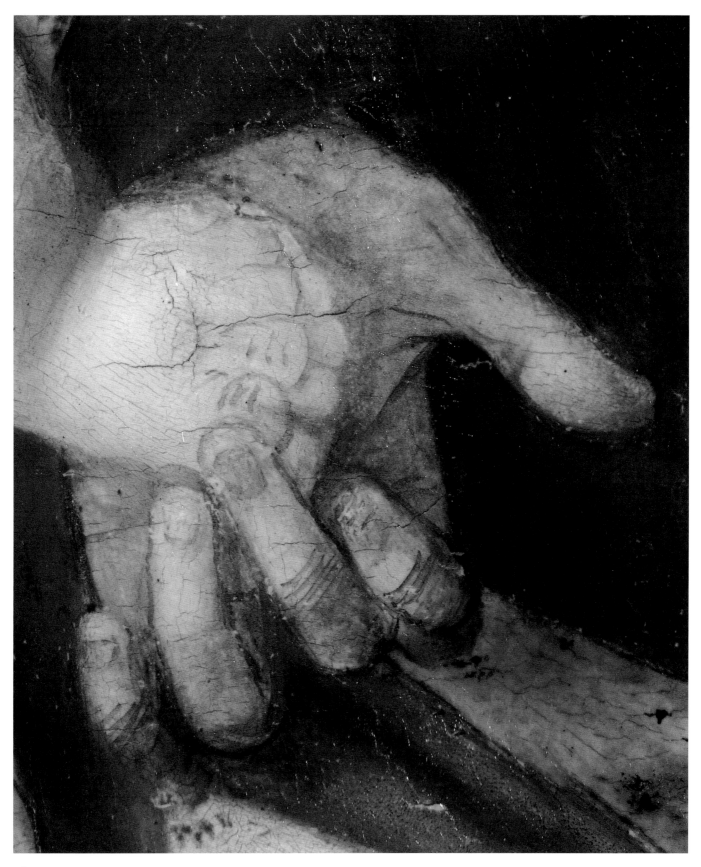

16

GIOVANNI BELLINI
The Madonna and Child
(The Dudley Madonna),
detail, infrared image
(before 2012 retouching)

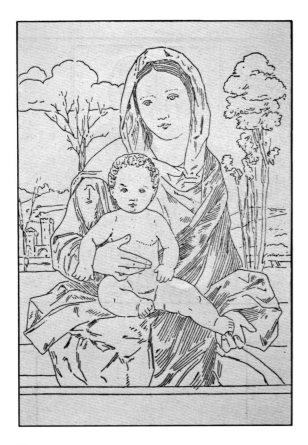

17
ANONYMOUS
The Madonna and Child, from
Salomon Reinach's *Répertoire*,
1910

arranging their planes, the twists ... the oppositions ... with a fine sense of logic".[45] The description, even though Cantalamessa was unaware of the existence of other versions, or indeed of the original from which the work he discussed derived, is quite perceptive, and he manages to bring out the truth about some of the formal aspects of the prototype. Indeed, it is not so absurd to bring up Benedetto Diana, a painter who trained in Venice in the early 1500s, producing works of very fine quality, and who employed, especially in the swirling folds of the robes, formal elements of a Tuscan milieu in the style of Fra Bartolomeo, from whom the old Bellini also drew freely.[46]

Just one year later Cantalamessa backtracked, as he became aware, when informed by Georg Gronau, who had seen it some time earlier at Elia Volpi's in Florence, of another version of the composition (Appendix II, copy B).[47] He was quick to see that it was "in composition very much like that of Santa Maria in Trastevere, and clearly seen to be done in dutiful imitation of Giovanni Bellini's style: it leads us to think that there existed an original by Bellini himself, from which both the minor paintings have derived; and it would not be surprising should another turn up".[48] He continues: "Every curious urge is tamed here, subdued by a purer and higher sentiment that has penetrated the soul, that is, by the hope that some day the original that we glimpse in these copies can be discovered, another work expressed by that great mind who honoured Venice. If it is not reckless to hazard a guess from these few elements about what point in life he had reached when he drew this fine group, I would say that he was in the first decade of the sixteenth century, when the wondrous old man accomplished the miracle of a higher ascent, despite his years; and certainly, whoever can imagine this composition graced with the refinement and beauty of Bellini, sees in his imagination a very rare jewel of art".[49] Cantalamessa seems to have reached with his imagination the very forms that we have been privileged enough to see first-hand.[50]

The question of a painting's chronology, when it arises from a study of copies after it alone, can have truly surprising answers. Is it because, in the presence of a copy, one is forced to look at the image in its purest form (and not its superficial, pictorial qualities), without the psychological pressure caused by the original, and other aspects therefore become more legible?

Carlo Gamba seems to confirm this idea in his monograph on Giovanni Bellini, published in 1937. He says about the same version (Appendix II, copy B), then with Duveen, and having in the meantime travelled to America: "Another of Bellini's compositions, which has clear links to Raphael, is the *Madonna* ... also in the Duveen collection I saw many years ago at Carlo Loeser's. The Child recalls the one of 1505-06, while

the Mother, with her slightly slumped, curved posture, seems conceived under the influence of some figure of Raphael's, but radically different in the pictorial effects, brought on by the sharp folds and the high-lighting in the drapery. The background with the town shows elements that are pure Bellini."[51] The ex-Loeser painting (copy B) had already by then undergone several conservation treatments, which make it seem that the various photographs of it, taken on different occasions, illus-trate different paintings.[52] The Duveen version ended up at the Norton Simon Museum in 1965, where, despite its glaring lack of quality, it is still attributed to Giovanni Bellini. The Duveen Brothers Records are con-served at the Getty Research Institute and there is a thick binder that concerns this version, which perhaps also became famous through the engraving that was included in Salomon Reinach's *Répertoire* (fig. 17), made around 1910, when the painting was still in Loeser's possession.[53] It is surprising how many *expertises* there are by legendary art historians (the likes of Bernard Berenson, Raymond Van Marle, Wilhelm Suida and Robert Langton Douglas), who emphatically attribute the painting to Giovanni Bellini.[54]

Carlo Gamba's truly inspired opinion is astonishing for its relevance and opens a window to a theme crucial for our Madonna, into which I intend to go further. And not without significance for the dating is the fact that Gamba immediately afterwards emphasizes "the Florentine style of foreshortening and balancing in the Dominican saint's pose" in the National Gallery's *Assassination of Saint Peter Martyr* (fig. 31), which has already been mentioned; Gamba reproduces it alongside the copy B of the *Madonna*.[55]

FROM GEORG GRONAU ON: A NEW LIGHT ON GIOVANNI BELLINI'S LATE ACTIVITY

Meanwhile, in 1928 Georg Gronau had published his book entitled *Spät-werke des Giovanni Bellini* (The late work of Giovanni Bellini), in the wake of which the significance (and catalogue) of Bellini's late activity radically changed.[56] Gronau laid to rest certain stylistic groupings that had cor-roded the catalogue of Bellini's late work, such as that of Pseudo-Basaiti, a figure created in 1903 (in the wake of Berenson) by Gustav Ludwig and Wilhelm von Bode.[57] Among Gronau's main re-attributions from Pseudo-Basaiti to late Bellini was the triptych with *Saint John the Baptist between Saint Jerome and Saint Francis* (fig. 18) originally from the Venetian church of San Cristoforo della Pace, later passing into the then Kaiser Friedrich Museum in Berlin, where it was very probably destroyed in 1945.

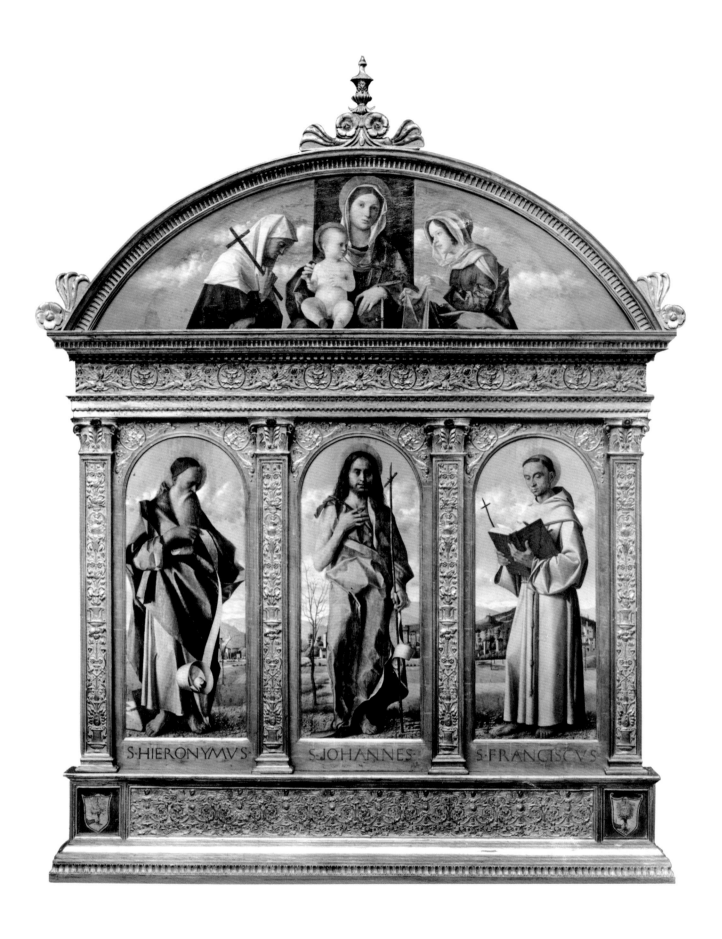

S·HIERONYMVS· S·IOHANNES· S·FRANCISCVS·

Gronau then settles his discussion on a group of Madonnas, some of which we have already come across – the Detroit Madonna (fig. 48) of 1509, the Brera Madonna (fig. 50) of 1510, the Madonna in the Galleria Borghese in Rome (fig. 51) and the Northbrook Madonna in Atlanta (fig. 12). Gronau can also be credited with making known the fascinating and still today little discussed *Madonna and Child with a donor* in the Muzeum Narodowe of Poznań (fig. 23), which we shall look at shortly.[58]

Finally, in 1955 the original version – the Dudley Madonna – was displayed at the Birmingham Museum, thus coming back into the limelight (though still handicapped, as mentioned, by overpainting: see fig. 3 and Appendix I, fig. III). By this time it was in the possession of Niel Rimington, who remained its owner until his death in 2009. It was seen in Birmingham by a number of Bellini scholars. While the British reception was lukewarm – Ellis Waterhouse saw it as representative of the "late Bellini workshop" and considered it merely a version and not the prototype of the one in Santa Maria in Trastevere (Appendix II, copy A) – Rodolfo Pallucchini in his 1959 monograph seems to have grasped its importance: "Certainly after 1510 is the Virgin holding the Child in her lap, seated against a backdrop of a countryside with tall trees, from the British collection of Niel Rimington … characterized by the complexity of the drapery steeped in light. One might say that Bellini was under Raphael's spell – a majestic rhythm and at the same time a distilled classical subtlety even in the expression of feelings."[59] Again, we meet the Raphaelesque leitmotiv that appears elsewhere in criticism of the composition (either in the original or in its copies). The illustration that Pallucchini used to accompany the image of the painting appears between the Detroit Madonna (fig. 48) and the one in the Metropolitan (fig. 25), which we have already come across several times.

Before delving into the subject already suggested by Gamba and Pallucchini – whether the spirit of Raphael should be evoked with regard to this Madonna by Bellini – we should mention that in the early 1960s there were still critics who lent credence to Berenson's late nineteenth-century idea: Fritz Heinemann, in his 1962 *Giovanni Bellini e i belliniani*, chock-full of audacious, to say the least, attributions (often never followed up), believed that the original of this composition had disappeared, that it had been "done no later than 1506", and that "the type of Virgin was derived from the Virgins in San Zaccaria and Northbrook. The position of the Child's legs and the position of the Virgin's hand are similar to those of the Northbrook Madonna." Heinemann has the merit, at least, of drawing up the first list of copies (even if inaccuracies are not lacking) of the composition, the original of which he believed lost. Our version, which he admits to "knowing only through a photograph", he thinks was

18
GIOVANNI BELLINI
Triptych with Saint John the Baptist between Saint Jerome and Saint Francis; lunette with the Madonna and Child between two saints,
c. 1502–05 (destroyed in 1945)
Formerly Berlin, Kaiser Friedrich Museum

39

"perhaps correctly" attributed by Berenson to Rocco Marconi. Curiously, Heinemann owned a print of the photograph taken in the 1950s (fig. 3; Appendix I, fig. III), which is characterized not only by the old retouchings but also by a curtailment of the parapet, removing Bellini's signature. Below his own print, which he archived under Rocco Marconi (Florence, Kunsthistorisches Institut, inv. no. 432457), Heinemann noted: "Rocco Marconi, Signed", a mistake that must have resulted not only from his never having seen the painting in the flesh and also from the absence of the signed parapet in the only image available to him. The attribution is repeated for the Accademia *Lamentation* (fig. 53) and for the Northbrook Madonna in Atlanta (fig. 12), even though Gronau had explained once and for all that this could not be the case. Felton Gibbons followed the same line of argument, although he showed greater penetration in his analysis of the forms of the Dudley Madonna: "Another Madonna attributable to Rocco Marconi, almost contemporaneous with that in Atlanta and also one of a family of versions, is in the Niel Rimington Collection Here the intent face of the Virgin, the ovaloid structure of her head, her long tapered fingers and the cramped features of the child are close enough to the Northbrook Madonna to make the attribution convincing. In the Rimington Madonna the forms are slightly fuller, the features a bit broader than those in Atlanta, and the Virgin breaks away from a rigidly frontal pose to twist in a gentle contrapposto. The tilt of her head, the swing of her right shoulder toward the picture plane, and the mollification of intensity of facial expression in both Virgin and Child lend an air of greater suavity to this work. These differences, though slight, seem enough to place the Rimington Madonna a year or two further into the Cinquecento than the Northbrook Madonna."[60] It is unfortunate that Gibbons still clung to older preconceptions, so Rocco Marconi's youthful catalogue (and Bellini's mature one) stay for the most part anchored to what Berenson had declared it to be nearly seventy years earlier. Otherwise, Gibbons could be considered amongst the few to have grasped the importance of this Madonna, which in Giovanni Bellini's oeuvre is truly the only one that "breaks away from a rigidly frontal pose to twist in a gentle contrapposto".

It is worth our while to go back to Berenson's catalogue of Rocco Marconi's works and to try to deal it a final blow. We have seen that it is unthinkable that the Northbrook Madonna (fig. 12) is by the same hand that signed the one in Strasbourg ROCVS DE MARCHONIB[VS] (fig. 11), though identical in composition. Furthermore, the Accademia's *Lamentation* (fig. 53) was until 1965 practically unrecognizable owing to the very heavy overpainting which altered the figures' physiognomy and even the landscape.[61] Therefore, both Berenson and Heinemann as

well as Gibbons evaluated this magnificent altarpiece only through a sort of distorting wrapper; and the same thing goes for our Madonna. It would be truly myopic today to persist in saying that this masterpiece of Venetian art from the early sixteenth century, the *Lamentation*, is the work of the mediocre Rocco Marconi. And not even Carrington's *Portrait of a Man* from the Norton Simon Museum in Pasadena (fig. 13) can take Marconi's name. I have never seen it in person, but formally (it belongs to the 'modern' genre of the 'looking over the shoulder portrait') it is fascinating – and the landscape with the tiny figures dressed in white in the background reminds me of those of Andrea Previtali (a student of Bellini's from Bergamo). I believe it may well be one of his portraits from the end of his period in Venice, around 1510.[62]

What Berenson did get right, it must be said, is the chronology of the paintings in question: they all belong to the same span of years, which corresponds to the last decade of Giovanni Bellini's life, at a time when Venetian painting was undergoing a rapid transformation. And what was happening with Bellini in this last phase of his life was already quite clear to Francesco Aglietti in the early nineteenth century: "And it was exactly in this period, which marked the most glorious moment in the splendour of Venetian painting, the years 1506 and 1507, that I believe that Giovanni made his marvellous decision at the highest point of his glory to become a follower and imitator of the disciples, and to emulate with new passion their success".[63]

I am convinced that the Madonna under examination belongs precisely to this phase, but to make this clear, as well as to explain Gamba and Pallucchini's correct reference to Raphael – and to fix it in the right place in Bellini's catalogue in order to establish the attribution finally – I will continue by examining this key five-year period for the old painter, as well as for Venetian painting, the lustrum 1505 to 1510.

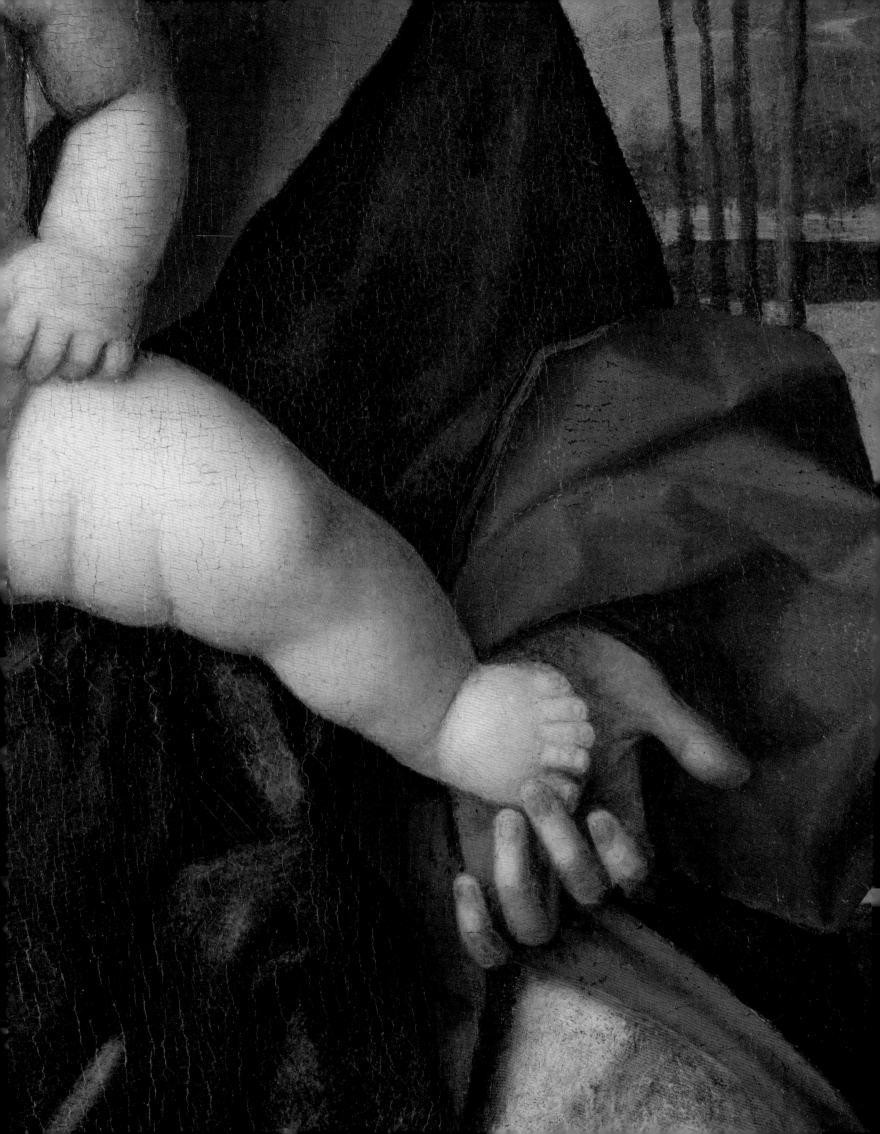

Giovanni Bellini, circa 1508

1505 is a year rich in signed and dated works by Giovanni Bellini, as well as documentation of his activity. It was a year when the old painter seemed to be coming to terms with his dialogue with Giorgione, which perhaps began prior to 1500 and was certainly in progress in the *Baptism* in Santa Corona in Vicenza, completed around 1501.[64] Thus, in 1505 we have the miracle of the San Zaccaria altarpiece (fig. 20), still structured in the fifteenth-century style, but with several references to the innovations of the younger painters: the heads of the two oak-like saints in the foreground are in poignant harmony with some of Giorgione's heads and in particular with the ones in the Vienna *Three Philosophers* (Kunsthistorisches Museum, inv. no. GG_111).

The rarefied atmosphere and the cold crystalline light are the same ones that make unforgettable the altarpiece by Lorenzo Lotto for Santa Cristina al Tiverone, also dated 1505. The group with the Virgin and Child is, compared with that of our Madonna, more Quattrocentesque; the folds of the robe slightly more angular, not as full and free. Nevertheless, in a single detail we can grasp the same poetic vein: the slender, elegant hand, the first joints grazed by the light, cups, like a protective shell, the baby Christ's foot without touching it (opposite and fig. 19) – of such high poetry, not in the least rhetorical or cloying (as often with works from his school), only Giovanni Bellini could be the creator.

Another of Bellini's altarpieces dated 1505 is in the Birmingham City Art Gallery (fig. 21).[65] Although critics of this masterpiece are not lacking, we stand again, as more than anyone else Giovanni Agosti has adamantly maintained, before a peak of Bellini's achievement and a highly complex weave of visual experiences.[66] The painting's many qualities – and even its innovations – were already recorded in a British sales catalogue of the early nineteenth century: "Hence it is observed in his life, that his latter

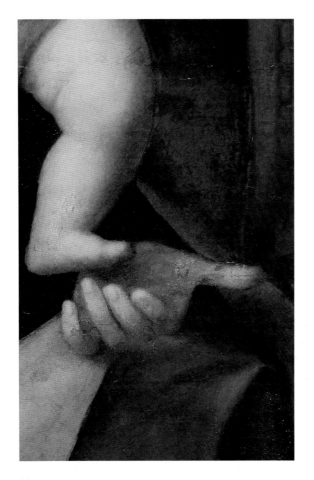

19
GIOVANNI BELLINI
The Madonna and Child enthroned, between four saints (The San Zaccaria Altarpiece), detail of fig. 20

20
GIOVANNI BELLINI
*The Madonna and Child
enthroned, between four saints*
(The San Zaccaria Altarpiece),
1505
Venice, San Zaccaria

were his best pictures; and this glorious specimen, in brilliancy and perfect preservation, may vie with any of his works in existence. In the close imitation of nature, the heads of the two saints display an astonishing degree of high-wrought force and fidelity; and, in the minute resemblance of still life, all the wonders of Gerhard Douw or Mieris, are surpassed by the antique variegated pavement, which conveys an idea not only of the solidity and enamel polish, but the coldness of marble itself."[67] The robes have wonderful deep tones of blue and purple, in which the eye can lose itself as in the night, and the drapery is both puffy and full and in other places crumpled, creating an effect reminiscent of Schongauer's figures. Overall, one breathes an atmosphere like that in the work of Giovanni Agostino da Lodi, while the compact, polished flesh drenched in light makes one think of Palma il Vecchio, whose style is here foreshadowed. A figure almost identical to this Saint Peter can furthermore be found in Lotto's altarpiece just mentioned. The pose of the Virgin and Child in the Birmingham altarpiece seems revived in the Dudley Madonna, but in the latter the pose is more dynamic, more lively, and therefore, one might say, more 'modern'.

A work that seems to be a stylistic precedent to the Birmingham altarpiece, not only because of the presence of the patron but also for the physical bearing of the Virgin and Child and the morphology of the clothing and the landscape, is the above-mentioned *Madonna and Child with a donor* in the Muzeum Narodowe in Poznań (fig. 23). Since Gronau's time, this painting has not been given proper accreditation in Bellini's oeuvre, and only rarely is it even mentioned.[68] Despite widespread surface abrasion, which also led to clumsy overpainting around the faces of the Virgin and Child, the overall quality is very high and upholds an attribution to Bellini himself around the turn of the century. It was a clever idea to seat the Virgin on a natural throne formed by a terrace finished by what looks to be a dry wall, showing up at the bottom left. The atmosphere is cold and crisp, as in all of Bellini's works that are contemporaneous with Giorgione's Castelfranco altarpiece (where the Madonna also wears an unusual red drapery). The way that the Child holds a flower tied to a string is also very clever, with the Mother reaching to catch it with her left hand – a dynamic similar to the one in the stunning *Madonna and Child* in the Burrell collection in Glasgow (acc. no. 35.4), which he had painted some years earlier. The Poznań Madonna could, in fact, predate 1502, the date inscribed (along with a declaration of his apprenticeship in the Bellini *bottega*) on a work by Andrea Previtali, very similar in design, in the Musei Civici of Padua (fig. 24).[69]

Previtali once again could be responsible for another take (prior to the Padua one) on the Poznań Madonna – the Madonna in the Metropolitan

Museum (fig. 25), formerly, as noted, at Fonthill Abbey, owned by Shaw-Stewart (and earlier by William Beckford). It is an excellent demonstration of strict Bellinesque orthodoxy, with some ingredients of Cima da Conegliano, that might sit well with the opening of Previtali's oeuvre – placing his *primizia* around the year 1500.[70]

In the Metropolitan painting the literal citation from the landscape in the London National Gallery *Madonna of the Meadow* – with a landscape comparable to that in the Poznań painting – does not conflict chronologically, as I am convinced that the National Gallery painting dates still to the very end of the Quattrocento, contemporary with the Pietà Donà dalle Rose in the Accademia, Venice (inv. no. 882), the *Lamentation* today on display in the Bode Museum in Berlin (inv. no. 4) and the grisaille *Lamentation* at the Uffizi (inv. no. 943). This is a dating also imposed by the Giovanelli Sacra Conversazione (fig. 22), which it seems possible to anchor to 1501.[71] This is quite a different phase in Bellini's life, though, and another story to be told at another time.[72]

The little-known Poznań Madonna (fig. 23) is also interesting because it shows similarities with our Madonna – in the figure of the Child, especially the right leg, and the way the mother clasps him. As we shall see with other later Madonnas, Bellini had no interest in making big changes to the posture and forms of the human figures. He was satisfied with making imperceptible variations between poses – we might almost say semitones, though able to change the melody radically. Of course, it should be noted that the dynamism of the figure of Christ in the Dudley Madonna is much more accentuated, and that the composition as a whole shifts from a static, granite-like pyramid to a spiral pyramid, a change that seems possible only if external experience had profoundly affected the old painter's disposition.

Albrecht Dürer bears witness how eager to learn the elderly Bellini still was at the time. In Venice from the end of 1505 to early 1507, Dürer wrote to his close friend Willibald Pirckheimer on 7 February 1506: "Among Italians, I have many good friends who warn me not to eat and drink with their painters. Many of them are my enemies and they copy my works in the churches and wherever they can learn about them. And then they criticize them and say that they are not of the old kind, and therefore are no good. But Sambelling [Giovanni Bellini] greatly praised me in the presence of many gentlemen. He would like to have something of mine, and he personally came to me and asked me to make him something, for which he would have paid me handsomely. And everybody tells me how he is a devout man, so I immediately feel well disposed toward him. He is very old, and is still the best in painting."[73] This famous passage bears witness to the desire for improvement that still

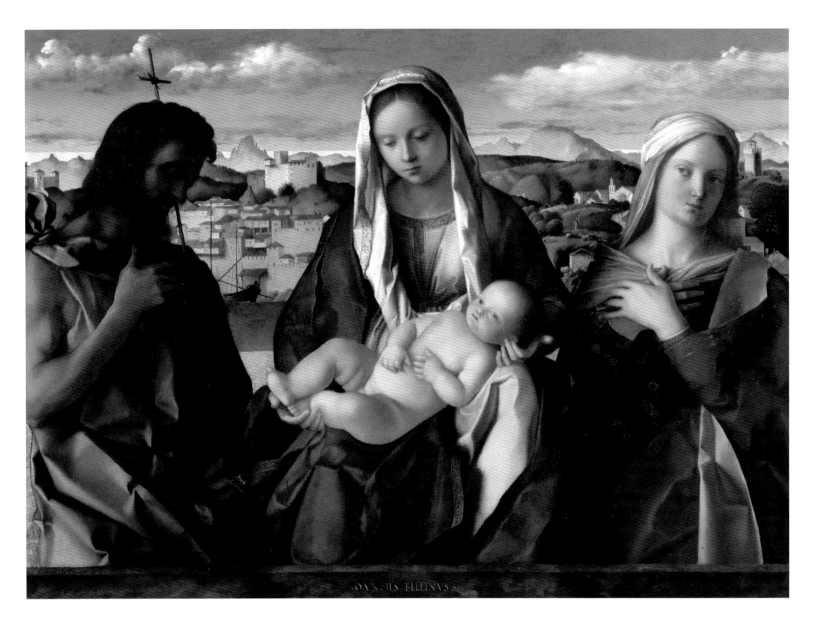

22
GIOVANNI BELLINI
The Madonna and Child between
Saint John the Baptist and a
female saint (The Giovanelli
Sacra Conversazione), *c.* 1501
Venice, Gallerie dell'Accademia,
inv. no. O 1552

23
GIOVANNI BELLINI
The Madonna and Child with
a donor, c. 1500
Poznań, Muzeum Narodowe,
inv. no. MO.2

burned in the seventy-five-year-old painter. Recently, I was admiring the Dudley Madonna together with Tilmann Buddensieg, who, letting his gaze wander over the blue cloak at the height of the Virgin's knee (one of the best preserved details of the painting; fig. 27), brought up the name of Albrecht Dürer, a compelling connection which I will try to explain in a rational way.

The most famous work that Dürer did while he was in Venice is without a doubt *The Feast of the Rose Garlands*, painted in 1506 for the church of the Germans in Venice, San Bartolomeo, and today in the Národní Galerie in Prague (fig. 26). Although it is damaged, and the painted surface shows many losses, one can still see traces of a close dialogue with the Venetian painters in the strong contrasts and the complementarity of

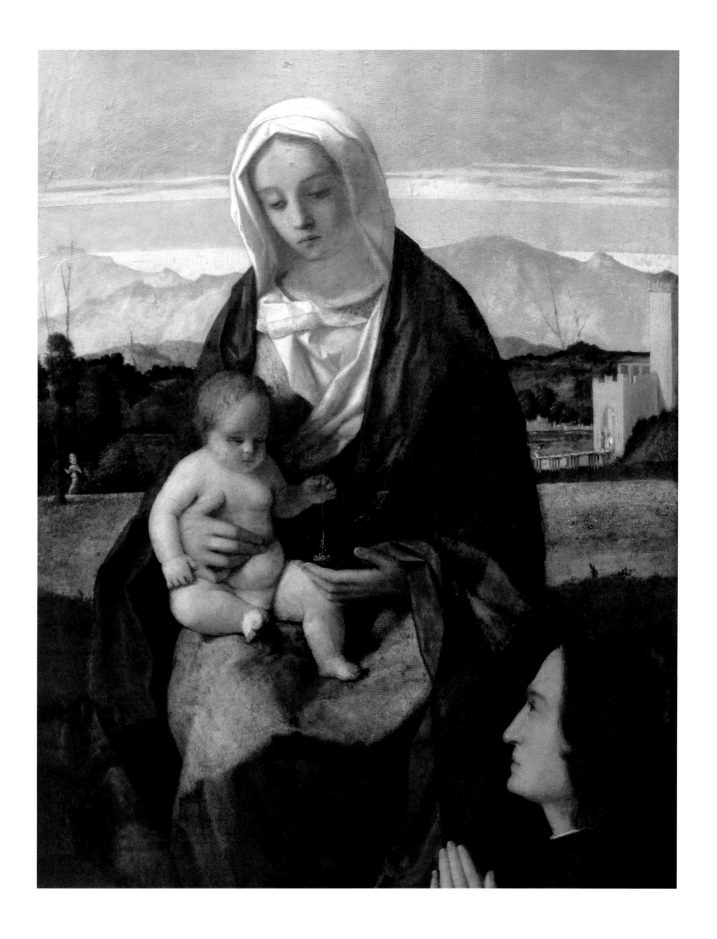

24
ANDREA PREVITALI
The Madonna and Child with a donor, 1502
Padua, Musei Civici, inv. no. 439

25
ANDREA PREVITALI
(here attributed to)
The Madonna and Child in a landscape, c. 1500
New York, Metropolitan Museum of Art, inv. no. 49.7.2

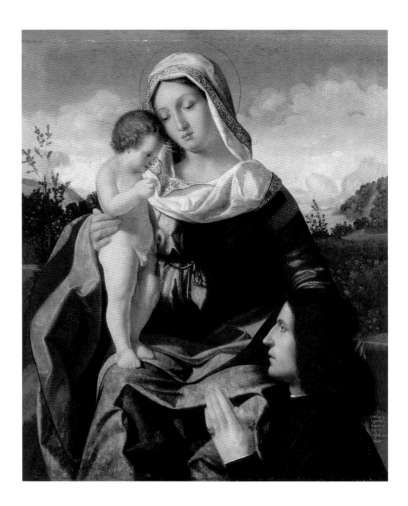

the colours. The Virgin's blue cloak, characterized by the nervous, electric twists of the folds and the alternation of zones of shade and cold light, could be a source for the 'icy' cloak of Bellini's Madonna (fig. 27), although Bellini's work is regulated to a greater degree by an interior geometry that makes the folds almost a treatise on stereometry. Thus it is no accident that Giorgio Vasari should state that Bellini's *Feast of the Gods*, painted in 1514 for Alfonso I d'Este's Camerino (today in the National Gallery of Art, Washington, inv. no. 1942.9.1), "in the style of the draperies" shows "a certain sharpness, in the German manner, but that is nothing strange because he was imitating a panel by the Flemish [*sic*] Albrecht Dürer, which in those days had been brought to Venice and placed in the church of San Bartolomeo; it is a rare thing, full of many beautiful figures painted in oil".[74]

Another work of Dürer's that provides food for thought on his relationship with Bellini is the unfinished *Salvator Mundi* in the Metropolitan Museum (fig. 28), possibly painted in Venice. Various formal aspects, from the 'icy' blue of the robe to the swirls of folds in the red cloak, in particular the 'rose' beside the left hand, vividly recall our Madonna.

GIOVANNI BELLINI, *CIRCA* 1508

Between August 1505 and the early months of 1506 Bellini was in close contact with Pietro Bembo, who had recently published his greatest literary success, *Gli Asolani*, with Aldo Manuzio. The Bembo and Bellini families had a long-standing relationship, as demonstrated by the presence of various of Jacopo Bellini's works in Bembo's collection in Padua.[75] Bembo acted as the intermediary between Giovanni Bellini and the Marchesa of Mantua, Isabella d'Este, who was eager to commission a new painting from the artist for her *studiolo* (which already displayed works by his brother-in-law Andrea Mantegna). On 27 August 1505 Bembo assured Isabella that, together with Paolo Zoppo, another of Bellini's close friends, he had "fought so hard that the castle, I believe, totally surrendered".[76] In any case, given Bellini's strong reluctance, fresh as he was from taxing negotiations with the Marchesa over the *Nativity* he had delivered to her, very considerable pressure was required to obtain the new painting.[77] Isabella wrote directly to the painter, giving him unconditionally "the assignment of making the poetic invention".[78] At first, Bellini seemed to consent and, according to Bembo, asked for information about the size and the direction of the light to be established in the painting. In exchange for his mediation, Bembo asked the Marchesa to seek to convince Mantegna (already ill; he would die the following year) to finish the canvases promised to his friend Francesco Cornaro, a Venetian nobleman who, he claimed, had a great deal of influence over Bellini. The *Portrait of a Man in a landscape* in the British Royal Collection (fig. 30) almost certainly dates from these months between 1505 and 1506, and it probably represents Pietro Bembo himself. Over a Memling-like base Bellini poured into this portrait, as portentous as it is conventional – though it is the only surviving portrait by Bellini to show a landscape in the background – all the experiences of these years, from Giorgione (the Terris *Portrait of a Man*, probably dated 1506 on the back,[79] now in the San Diego Museum of Art, inv. no. 1941:100) to Dürer (*Portrait of a Man*, dated 1506, Genoa, Palazzo Rosso, inv. no. PR 47).

Meanwhile, in February 1506, Bellini was working on an *ancona* (altarpiece) commissioned by Giacomo Dolfin for his funerary chapel in San Francesco della Vigna in Venice. The result was the *sacra conversazione* dated 1507 (fig. 29), still *in situ*, with the figures arranged in a traditional way clearly showing the contribution of the workshop. But Bellini's poetry finds full expression in the astonishing landscape. According to Aglietti, "Giorgione's power and sublime *sprezzatura*, perfectly paired with Titian's mellowness and truth, and made precious by all the charm and beauty of Bellini, fill this painting with so much light".[80] By that date, Titian was about eighteen years old and already quite active.[81]

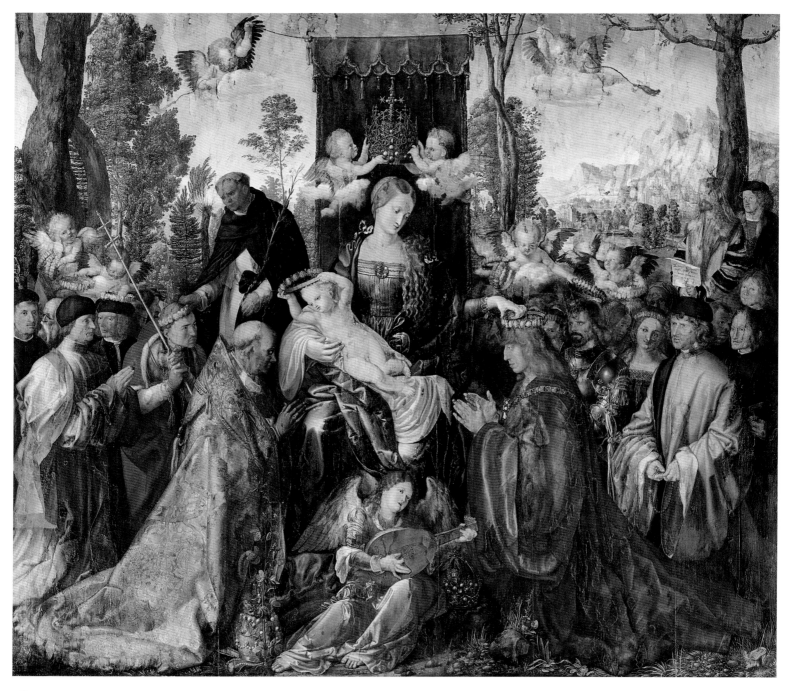

26
ALBRECHT DÜRER
The Feast of the Rose Garlands,
1506
Prague, Národní Galerie,
inv. no. o 1552

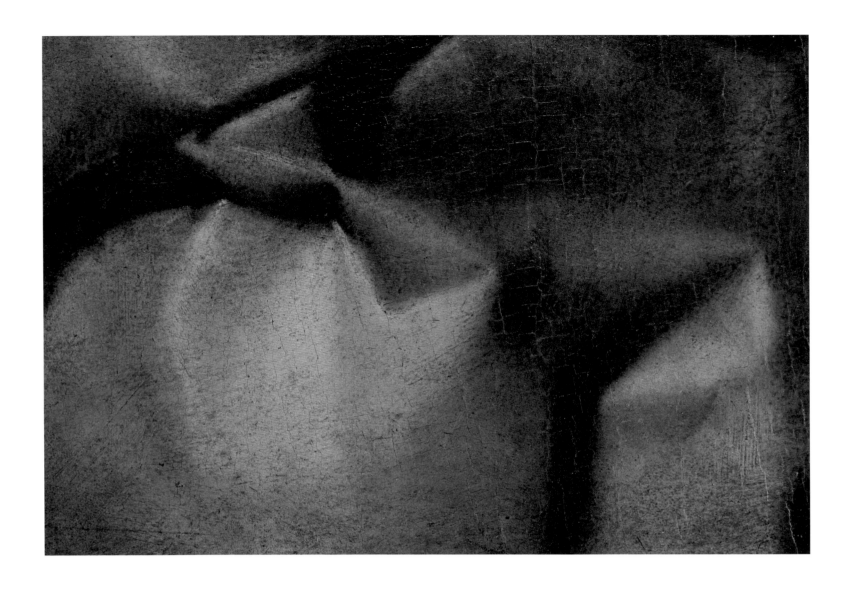

27
GIOVANNI BELLINI
The Madonna and Child
(The Dudley Madonna), detail

The presence of Titian can be discerned in Bellini's *Assassination of Saint Peter Martyr* (fig. 31), for example – which we may recall as one of the pictures Berenson attributed to Rocco Marconi – datable to about 1507 through comparison with the grisaille in Washington (figs. 34–35), which we shall discuss shortly. It certainly predates 1509, the year that is inscribed on the back of the workshop version in The Courtauld Gallery in London (inv. no. P.1947.LF.29). Bellini's *Assassination* is similar in composition to Titian's *Flight into Egypt* in the Hermitage in St Petersburg (inv. no. GE 245), a large canvas very likely commissioned by Andrea Loredan, a key figure in Venice during those years, whom we shall meet again further on.[82] Linking Titian's painting and Bellini's there is the same use of a frieze of figures and of foliage that covers much of the painted surface and, on one side, a mountainous landscape in the distance.

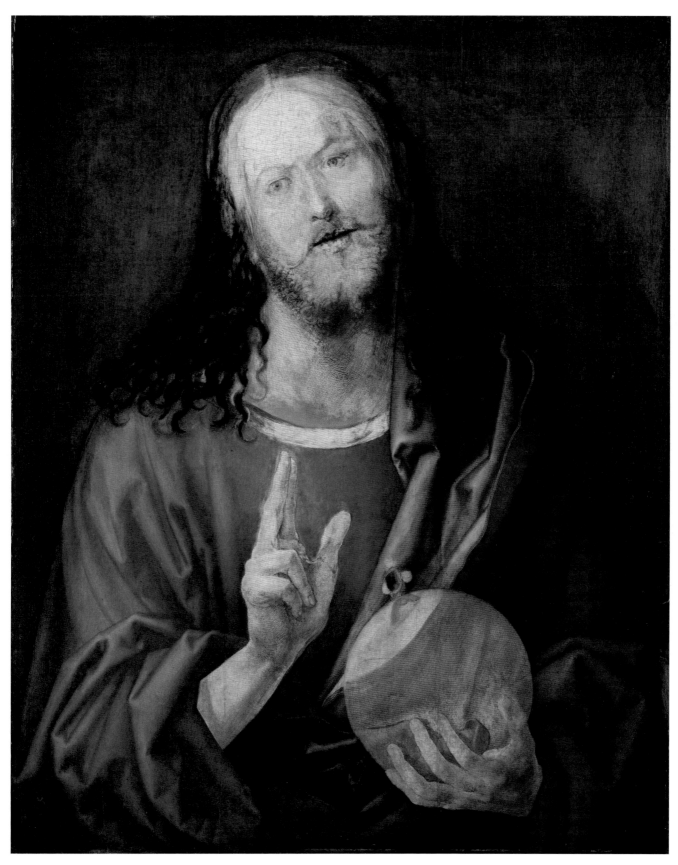

28
ALBRECHT DÜRER
Salvator Mundi, c. 1505
New York, Metropolitan
Museum of Art, inv. no.
32.100.64

IOANNES BELLINVS ·
· M·D·VII ·

29
GIOVANNI BELLINI
AND WORKSHOP
*The Madonna and Child
between four saints and a
donor* (The Dolfin Sacra
Conversazione), 1506–07
Venice, San Francesco della
Vigna

In Bellini's painting, the landscape on the left (fig. 32) rises up behind a walled and turreted town and bears a very strong resemblance to that of the Dudley Madonna, in particular the part on the left (fig. 33) where, in contrast with the other side, which is completely deserted, the human presence is palpable.[83]

In May 1506, there is one last testimony of Bellini in direct contact with Bembo, who just a few weeks later left Venice for good and accepted the temporary hospitality of the Dukes of Urbino before moving on to Rome. It was in Urbino that he met the young Raphael.

From the time of Bembo's departure, in the summer 1506, there are more or less obvious signs of further change – for the umpteenth time – in Bellini's art, taking him towards a more pronounced classicism which

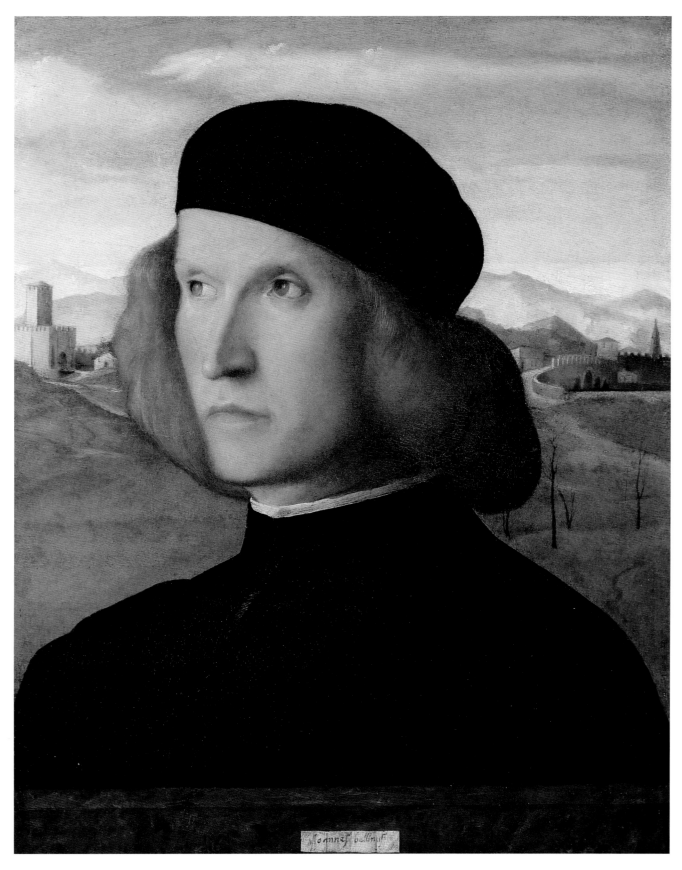

30

GIOVANNI BELLINI
Portrait of a man in a landscape
(Pietro Bembo?), *c.* 1506
Windsor Castle, Royal
Collection, inv. no. RCIN 405761

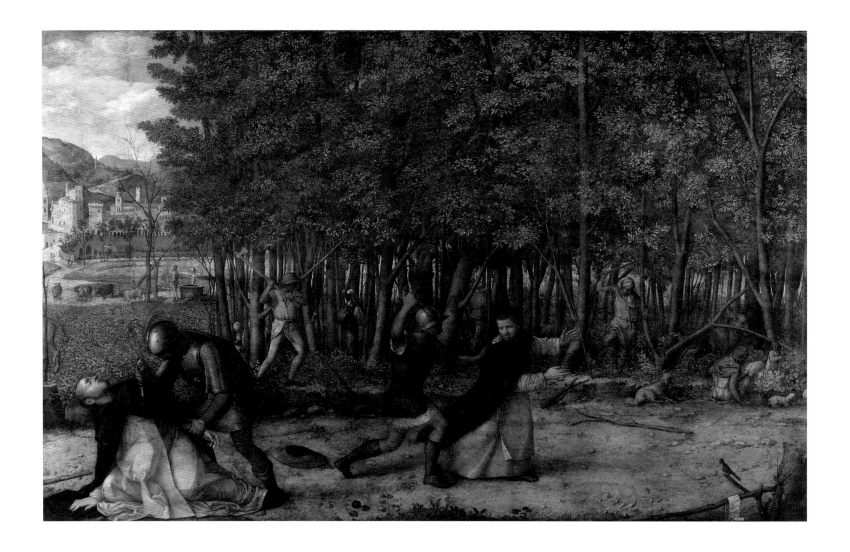

31

seems to culminate in our Madonna. We must not forget that 1506 was a decisive year for the Italian artistic scene as a whole, starting with the earth-shaking discovery of the *Laocoön* statue group in January in Rome, "in a vineyard near Santa Maria Maggiore". The image of it was disseminated with astonishing speed, and its impact was immediate, even in Venice.[84] There were also copies of the cartoons of Michelangelo's *Battle of Cascina* in circulation, the first echoes of which had probably reached Venice already by 1506–07.[85]

On 13 September 1506 Mantegna died, having finished only one of the canvases for Francesco Corner (today in the National Gallery, London, inv. no. NG 902). The commission was passed on to Bellini, who finally found the nerve to measure himself against his brother-in-law with a profane and archaeological subject (having declined to do so in 1501).[86] The result is the marvellous *Continence of Scipio* at the National Gallery of Art in Washington (fig. 34), in which a citation from an ancient

GIOVANNI BELLINI, *CIRCA* 1508

32
GIOVANNI BELLINI
The Assassination of Saint Peter Martyr, detail of fig. 31

33
GIOVANNI BELLINI
The Madonna and Child (The Dudley Madonna), detail

candelabrum formerly belonging to Domenico Grimani has been recognized.[87] Probably produced between the end of 1506 and the beginning of 1507, this canvas shows, especially in certain details (fig. 35), a surprising freedom in the way the figures occupy the space and atmosphere and a billowing and spiral swelling of the drapery recalling some of Raphael's creatures (and not to be explained in the usual way by reference to Giorgione alone).

The same Raphaelesque reverberations can be glimpsed in a work that seems to be of the same date, the *Madonna in Glory with eight saints* in the church of San Pietro Martire at Murano (for the past few years on deposit in the Accademia in Venice; fig. 36). The saints wear voluminous drapery and are arranged convincingly in a semi-circle; they are twins of the grisaille figures in the Washington canvas – had Pietro Bembo perhaps been able to keep Bellini abreast in good time of developments in Urbino?[88]

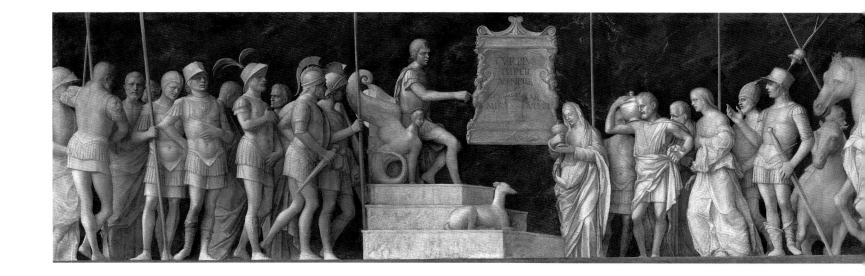

We must not forget, however, that the forge that was casting the moulds of the 'modern manner' was at that time in Florence. There is a work by Raphael born of this conjunction that seems to me to harmonize miraculously – notwithstanding the intrinsic differences between the two artists more than fifty years apart in age, even if sometimes compared for their common trait of rapidly and constantly changing their skin – with the Dudley Madonna: this is the *Saint Catherine of Alexandria* in the National Gallery, London (fig. 37), which came to the museum from the collection of William Beckford (by now an old acquaintance of ours) at Fonthill Abbey.

This work, painted around 1507, just before Raphael went to Rome, has the same format as Bellini's painting: the upper part of the female bust rises from the shoulders above the median line of the horizon, which is occupied by trees, houses and distant, bluish mountains. The spiral movement (naturally, more free and more accentuated in Raphael's work) pushes the left-hand side of the bust back, creating a depth that the gaze takes in all the better owing to the warm-coloured band of the cloak that climbs up the shoulder like a mule trail then to drop off the crest.

The red-yellow and orange-green-blue scheme of the robes in *Saint Catherine* reveals a very distinct colour sense: had the ultra-receptive Raphael caught sight of Bellini's or Giorgione's paintings in these years, or even just listened avidly to Bembo's description of them? Another work of Raphael's that seems relevant to this discussion is the Uffizi *Madonna del Cardellino* (fig. 38), with its pyramidal figure that rises above the horizon with an almost dancing movement of the shoulders, and the tall trees at the sides almost framing the composition.

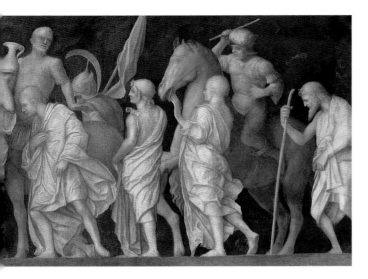

34, 35
GIOVANNI BELLINI
The Continence of Scipio
(and detail), *c.* 1506–07
Washington, National Gallery
of Art, inv. no. 1952.2.7

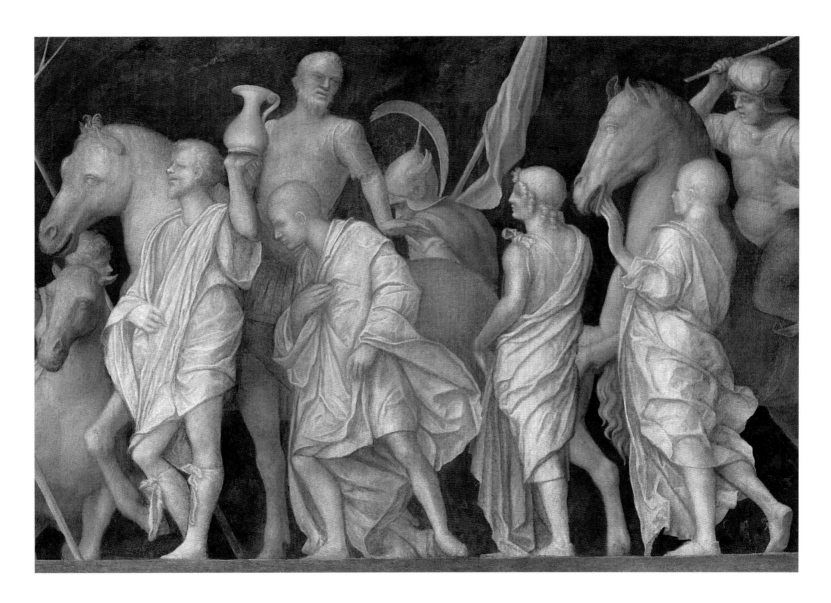

36
GIOVANNI BELLINI
The Madonna in Glory with
eight saints, c. 1507
Murano, San Pietro Martire
(on deposit, Venice, Gallerie
dell'Accademia)

37
RAPHAEL
Saint Catherine of Alexandria,
c. 1507
London, The National Gallery,
inv. no. NG 168

GIOVANNI BELLINI, *CIRCA* 1508

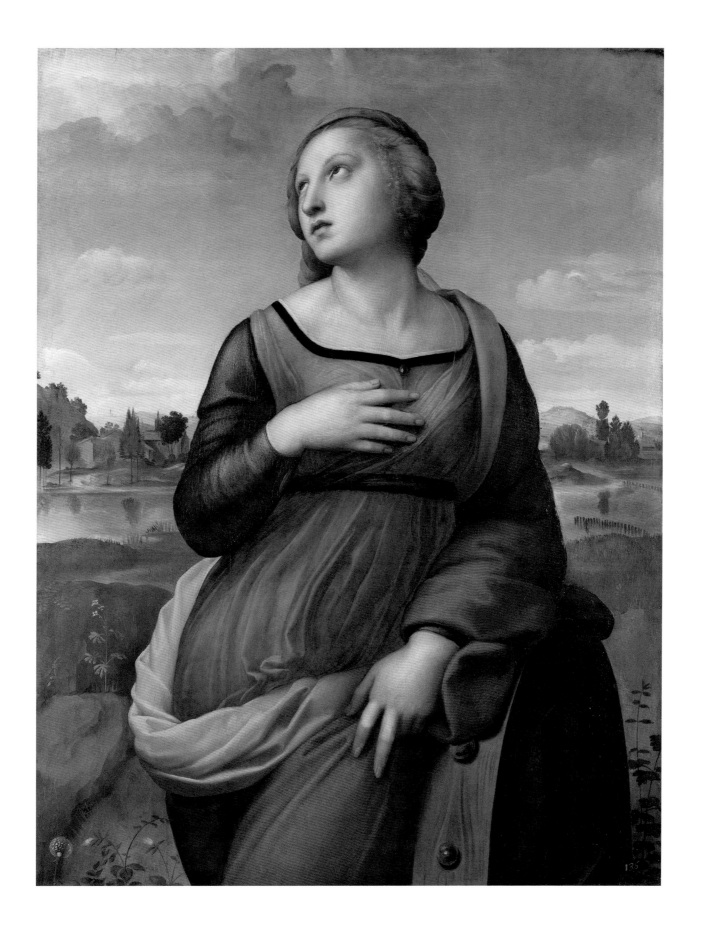

38
RAPHAEL
La Madonna del Cardellino,
c. 1506–07
Florence, Galleria degli Uffizi,
inv. no. 1447

39
TITIAN
Tobias and the Archangel, c. 1508
Venice, Gallerie dell'Accademia,
inv. no. 1171

Of course, simplifying, all these spiral-shaped creatures start with Leonardo, who had conceived them thirty years earlier (the Benois *Madonna* at the Hermitage, St Petersburg, inv. no. GE-2773). Leonardo's influence was felt in Venice as early as the 1490s. Take, for example, Giovanni Agostino da Lodi: having trained under Leonardo and Bramantino, in his altarpiece for the Murano ferrymen formerly in the church of San Cristoforo della Pace and today in San Pietro Martire in Murano, which he painted around 1500, one cannot help but notice that there are already present certain forms of the 'modern manner' – in the group with the Virgin and Child, the spiral development of the drapery, the yellow fold climbing up the shoulder, and the almost dancing gestures. But the native artists were not yet ready to embrace them.

On 23 February 1507 Bellini lost his brother Gentile, who asked Giovanni in his will, dated 18 February, to finish his painting of *Saint Mark's Last Sermon in the Square of Alexandria* for the Scuola Grande di San Marco, today in the Pinacoteca di Brera (Reg. Cron. 160).[89] The year 1507, just when Marin Sanudo called him the "most excellent painter in Italy", might symbolically represent a further turning-point for the old painter: his brother-in-law Mantegna had died a few months earlier, so that Bellini was among the last of the champions of a civilization – that of the Quattrocento – now in its decline. For him the time had come, now that he was free from the constraints of the past, to open up to the new world.

However that may be, what is touching about Bellini is to see how, in spite of his heroic efforts to remain up to date, almost to make a journey forward in time, everything is restrained and measured, and there persist traces of that "perspectival synthesis of form and colour" first introduced by Piero della Francesca, which had enabled Giovanni nearly forty years earlier to lay the foundations in Venice for an extraordinarily long and flourishing tradition of painting.

But how might Giovanni Bellini have come to know of these forms of Raphael's? In the spring of 1508 Fra Bartolomeo was in Venice, having probably been summoned from Florence by his Dominican brethren at San Pietro Martire in Murano to make an altarpiece. Bartolomeo was a key figure for early sixteenth-century Florence; just beforehand, as Vasari tells us, the young Raphael had greatly admired the friar and visited him every day.[90] In early 1508 Fra Bartolomeo would make his way to Venice with a wealth of important new ideas to share and disseminate, and which, obviously, Bellini was not the only one to heed; one need mention only a handful of important paintings that can be dated to this time, in which the new and radical ideas of the 'modern manner' break through. We have Sebastiano del Piombo, who, already a few years earlier, with

40
PALMA IL VECCHIO
*The Madonna and Child
enthroned between two saints
and two donors, c.* 1508
Rome, Galleria Borghese,
inv. no. 157

The Judgement of Solomon now at Kingston Lacy (National Trust, inv. no. 1257074), very probably commissioned by Andrea Loredan for the *portego* of his palace on the Grand Canal, had shown that he was abreast of what was happening on the other side of the Apennines; he then became almost unconditionally classical in his organ shutters for the church of San Bartolomeo (on deposit at the Accademia, Venice) – and, in fact, went to Rome very soon afterwards, in 1511. Or there is Titian's *Adulteress*, now in Glasgow (Kelvingrove Art Gallery and Museum, inv. no. 181), in which the dancing figures seem almost to be performing gymnastics of opposition. In all probability also from 1508 is Titian's *Tobias and the Archangel*, in the Accademia, Venice (fig. 39), which – as Johannes Wilde in particular had stressed – bears the Bembo family crest at the bottom (so it

GIOVANNI BELLINI, *CIRCA* 1508

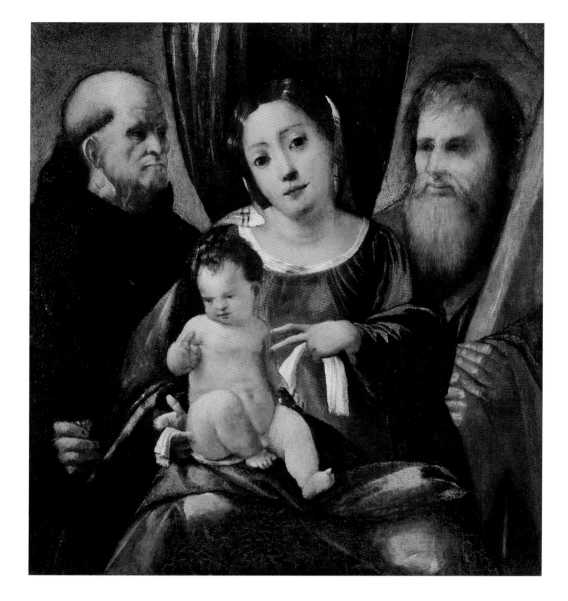

41
DOSSO DOSSI
*The Madonna and Child between
Saint Benedict and Saint Andrew,
c.* 1511
Florence, Galleria Palatina di
Palazzo Pitti, inv. no. 309

is not unlikely that it had been commissioned by Pietro Bembo himself):
it is a marvellous work by the very young Titian, who was fully attuned
to the most innovative expressions of the 'modern manner', between
'Florentine spirals' and an all-over sense of nature (flowers, animals,
plants, minerals and sunlight), which manages to arrive at a fusion of
Giorgione and Dürer.[91] The great spiral (accompanied with smaller spi-
rals of drapery) created by the monumental and muscular figure of the
Archangel is formally a perfect parallel to the Dudley Madonna, but much
freer from the restrictions of geometry.

A then very young artist who managed nonetheless to achieve a fusion
of these various experiences was the Bergamasque Jacopo Negretti,
later known as Palma il Vecchio. In his *Madonna and Child enthroned*

42
FRA BARTOLOMEO
*God the Father in Glory between
Saint Mary Magdalene and Saint
Catherine of Siena*, 1508–09
Lucca, Museo Nazionale di
Villa Guinigi, inv. no. 88

between two saints and two donors in the Galleria Borghese in Rome (fig. 40), which Roberto Longhi attributed to Palma in 1926, and which in Alessandro Ballarin's opinion can be dated to 1508, "the frontal and symmetrical layout is already developed on different planes of depth, and the foreground is occupied by triangular masses" seen very close up.[92] So it is no coincidence that there should be several similarities between this youthful work of Palma's (who also trained in Bellini's milieu) and the Dudley Madonna. Observe, for example, in addition to the similar group with the Virgin and Child, Saint Barbara on the left, with her left shoulder receding into the background and her face slightly tilted, and also the trees – one tall, the other low – that are rooted in her orange-coloured cloak: one cannot help but think of the 'modern' formal layout of Bellini's Madonna. That the Dudley Madonna soon after its creation became a point of reference for other artists, even outside Venice, is also proved by comparison with an early work by the Ferrarese Dosso Dossi, which has been characterized as from his most 'Venetian' phase. This is the *Madonna and Child between Saint Benedict and Saint Andrew* in the Palazzo Pitti, Florence (fig. 41), dateable to around 1511.[93] It is striking how Dosso Dossi has drawn inspiration from Bellini in his own setting of the Madonna with the Child in her lap, and in particular in the pose of the head and languid expression of Mary, with her gaze so delicately directed towards the viewer.

The year 1508 is remembered for the frescos of the Fondaco dei Tedeschi, where Giorgione initially, and then Titian, in parallel with Michelangelo in the Sistine Chapel and Raphael in the Stanza della Segnatura, established the canon of the 'modern manner'. In December 1508 Giovanni Bellini, himself finishing canvases in the Palazzo Ducale (lost in a fire later in the century), appointed three painters to an arbitration panel set up to evaluate Giorgione's frescos. Bellini wisely chose three painters from three different generations – Lazzaro Bastiani, his contemporary, Vittore Carpaccio, who was born in the 1460s, and Vittore Belliniano, a young pupil of his (the latter two were assisting Bellini in the Palazzo Ducale project).[94]

Fra Bartolomeo had come to Venice to execute an altarpiece for the Dominicans of Murano.[95] Because the patron, Bartolomeo d'Alzano, prior of the Dominican convent of San Pietro Martire, died in December 1508, and in that same month the League of Cambrai was formed to attack Venice, the altarpiece, representing *God the Father in Glory between Saint Mary Magdalene and Saint Catherine of Siena*, perhaps one of the Dominican friar's greatest achievements, was never delivered to Venice. Today it is in the Museo Nazionale di Villa Guinigi in Lucca (fig. 42). A work by Fra Bartolomeo similar to the Venetian altarpiece, of more or

less the same period (it is dated 1509), is the *Madonna and Child enthroned between Saint Stephen and Saint John the Baptist* in Lucca Cathedral (fig. 44). Critics have often pointed out this painting as indicative of an exchange with Giovanni Bellini, and rightly so.[96] We can imagine a natural and immediate understanding between the two, considering also that Bellini felt very at home with the Dominicans, the religious order to which perhaps he was closest (he was buried in the Dominican monastery of Santi Giovanni e Paolo in Venice).[97] Fra Bartolomeo's composition, steeped in colour, has a geometrical structure, forming a large pentagon that has at its top the oval head of the Virgin just as in Bellini's altarpiece for San Zaccaria (fig. 20).

On the other hand, as Francis Russell has pointed out, this group of the mother and her son cannot help but bring to mind – in mirror image – the Dudley Madonna in particular.[98] The Child, with that gymnast's movement of the legs and that direct and spirited gaze directly to the viewer, seems like a brother of the one in Bellini's work. Indeed, a preparatory drawing by Fra Bartolomeo in Paris (fig. 43) for the Madonna

45
GIOVANNI BELLINI
The Madonna and Child
(The Dudley Madonna),
detail

46
GIOVANNI BELLINI
The Madonna and Child
(Detroit), detail of fig. 48

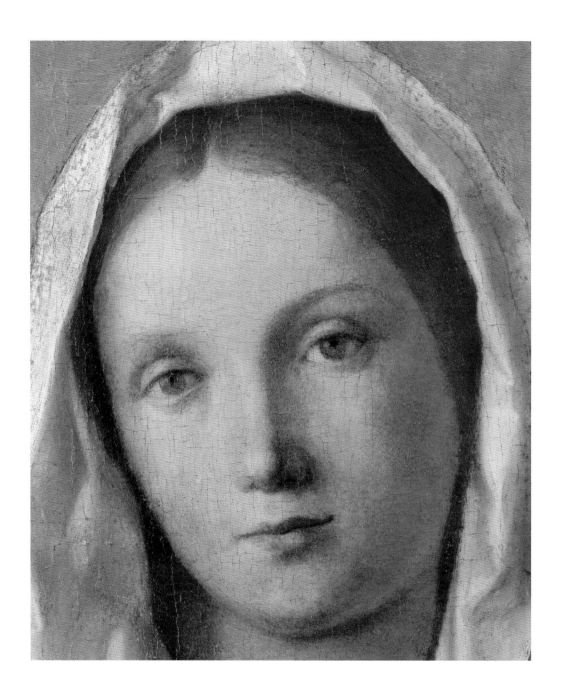

and Child of the Lucca altarpiece (fig. 44), with its pyramidal structure and the twisting folds of drapery, seems in direct dialogue with the forms of the Dudley Madonna.[99] Therefore it seems very likely that the 'modernity' of the Dudley Madonna was also the consequence of a meeting with the Dominican friar. Bellini's efforts to modernize might well have been inspired by a commission from an important patron who was aware of the revolutions in progress, and who had to be satisfied.

To conclude this discussion of the links between Fra Bartolomeo and Giovanni Bellini, and the suggestion of the importance of patronage for

certain sudden formal changes, I would like to establish with the greatest possible certainty the chronology (and therefore also the attribution) of the Dudley Madonna through a comparison with other dated works. The work closest to the Dudley Madonna – in terms of subject as well – is the Detroit Madonna (fig. 48) of 1509, with which we are already acquainted.

Just compare the two heads (figs. 45–46): the distribution of the light and shade is identical, the nose slender, the mouth small, the expression in the eyes sad but brave, with the highlight in the iris. We realise that not only is the same artist at work and the two paintings are very close in

47
The Madonna and Child
(The 'Gypsy' Madonna), *c.* 1509
Vienna, Kunsthistorisches
Museum, inv. no. GG_95

GIOVANNI BELLINI, *CIRCA* 1508

48

GIOVANNI BELLINI
The Madonna and Child, 1509
Detroit, Institute of Arts,
inv. no. 28.115

49
TITIAN
*The Madonna and Child
enthroned with a musician
angel, c.* 1509–10
Oxford, Christ Church,
JBS 718

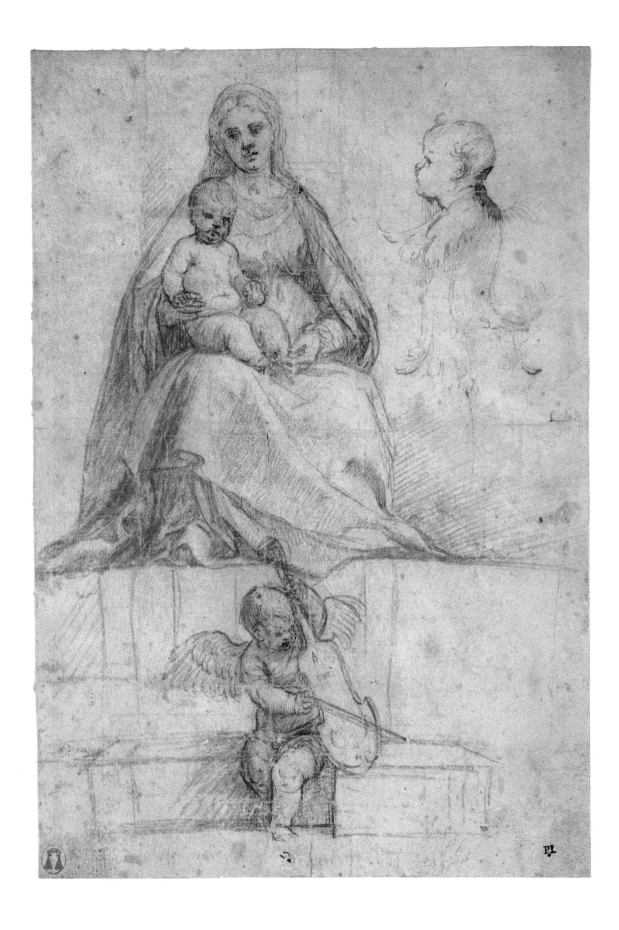

GIOVANNI BELLINI, *CIRCA* 1508

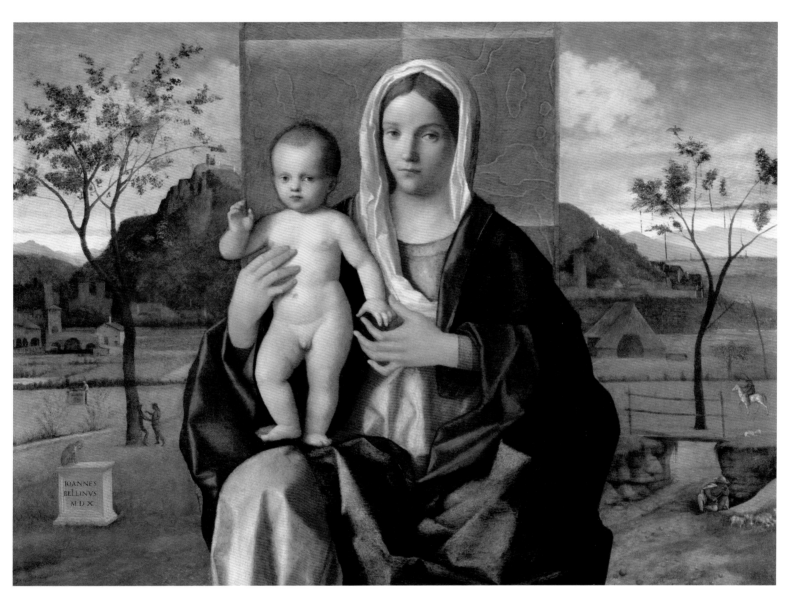

50
GIOVANNI BELLINI
The Madonna and Child, 1510
Milan, Pinacoteca di Brera,
Reg. Cron. 298

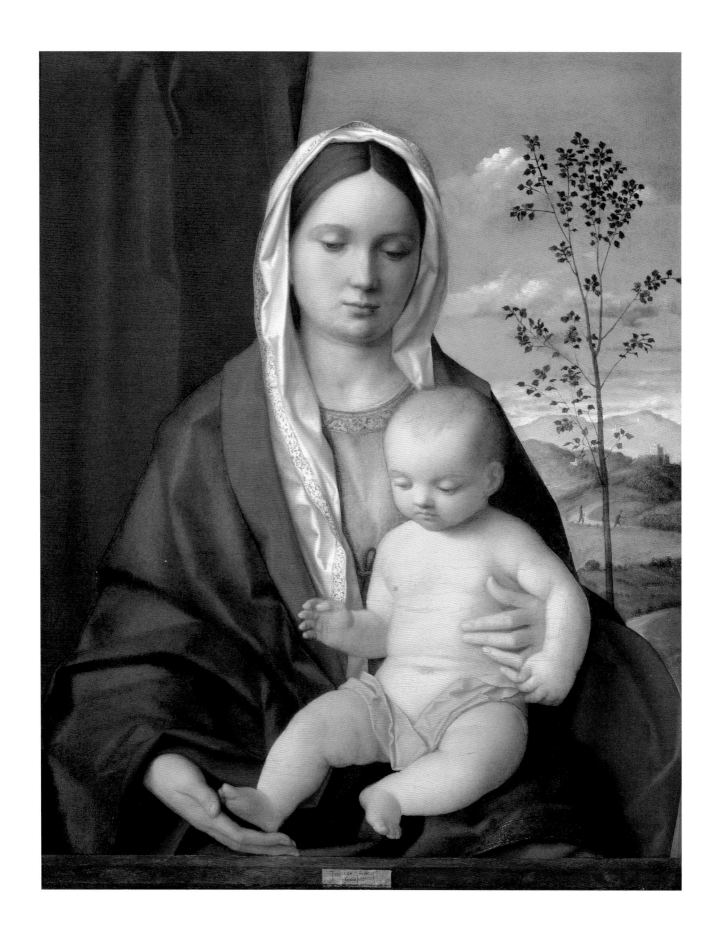

GIOVANNI BELLINI, *CIRCA* 1508

time, but there is also the same ideal of female beauty, and perhaps even the same model, one who returns again in the *Woman at the Mirror*, a late work (of 1515) now in the Kunsthistorisches Museum in Vienna (inv. no. GG_97). The monumental Detroit Madonna seems to have come just after the Dudley painting, even if, from a formal point of view – despite the sweeping volume of the drapery and the strong diagonal of the lining of the cloak on the shoulder – it is not nearly as bold. Could it be that the elderly Bellini, after the heady experience of 1508, wanted to backpedal, to return to his old certainties? However, at this very time he was also locked in a trajectory parallel with Titian's, as comparison with the formal scheme of the Vienna 'Gypsy' Madonna (fig. 47) demonstrates.[100] As Giovanni Agosti has argued, the landscape of the Detroit Madonna seems truly to have been 're-worked' ("*reconzato*"), which is so different from that of the Dudley Madonna, but also from that of the Brera Madonna painted a year later (fig. 50).[101]

A red-chalk drawing for a *Madonna and Child enthroned with a musician angel* at Christ Church, Oxford (fig. 49) fits well into this discussion of the relationship between Bellini and Titian in these years. In fact here we can see how Titian interpreted and reworked the Dudley Madonna, increasing her weight and elevating her to monumental status.[102] The tilt of the two heads is very alike, based on two axes slightly convergent at the top, as are the positions of the Virgin's hands, one supporting the baby Jesus and the other caressing his foot. The same dialogue between the young Titian and the old Bellini seems to run through the beautiful but ruined Brera Madonna (fig. 50), dated 1510, which borrows the layout of the Detroit Madonna (monumentalizing it even more) and the horizontal format, more suited to a large and open landscape in the background. Here, as in the Dudley Madonna, the tonal balance of the colours in the drapery is subtle and finely adjusted, between the intense, 'icy' blue of the cloak and the copper of its lining, the cherry red of the robe and the white veil – not to mention the effect of Jesus's white, porcelain-like skin, slightly paler than his mother's.

To me, it seems impossible that the Galleria Borghese *Madonna and Child* (fig. 51) should belong to the same period as the Dudley, Detroit and Brera Madonnas, although it is frequently compared with them and dated around 1510.[103] Here, by contrast, there is no resemblance to Raphael's and Titian's 'modern manner', not even in the expansion of the volumes and the grandiosity of the gestures that increasingly characterized Bellini's works during the five years examined here. Moreover, it is significant that the three 'modern' and increasingly monumental Madonnas painted by Bellini between 1508 and 1510 all look – as does the child Jesus – straight out towards the observer, while the Borghese

51
GIOVANNI BELLINI
The Madonna and Child,
c. 1500–02
Rome, Galleria Borghese,
inv. no. 176

Madonna still conserves, in that lowered gaze, all the shyness typical of Bellini's works of the previous decade (also of Giorgione's youthful Madonnas). Although, in terms of composition, it seems to mirror the Dudley Madonna, it seems to me more appropriate to place the Borghese Madonna about a decade earlier, at the turn of the century, among a group of similar paintings, analysed above, such as the Giovanelli Sacra Conversazione (fig. 22) from about 1501, or the Poznań Madonna (fig. 23), painted before 1502.

Another work known to date from 1510 (thanks to an engraving of the nineteenth century bearing a dated *cartellino* that no longer exists) is the Procuratia di Ultra altarpiece preserved in the Walters Art Museum in Baltimore (fig. 52).[104] This painting was done largely by the workshop, and it is of particular interest to us because the group of the Virgin and Child (who stares at the viewer) seems to be based – albeit in mirror image and not exactly – on a design like that of the Dudley Madonna, which would seem to confirm that this is from before 1510.[105]

Finally we should turn to the *Lamentation* in the Accademia in Venice (fig. 53), which has already been mentioned a number of times above. In Luciano Bellosi's fitting and illuminating words, "the figures dispose themselves with great confidence, they freely breathe in the surrounding atmosphere and they express a composed and sublime sorrow. Their sheer masses have a sense of monumentality that needs no flaunting. One wonders if there was a meeting of minds with Fra Bartolomeo, who was in Venice in 1508. I am thinking in particular of the absolute master-piece of the Florentine friar that is the God the Father and Saints Mary Magdalene and Catherine of Siena at the Pinacoteca di Villa Guinigi in Lucca [fig. 42]. But to an even greater degree, it seems to be in line with the Raphael's ambitious thinking at the time of the *Disputa*. The *Lamentation over the Dead Christ* that we are examining is certainly a late work by Giovanni Bellini and the attribution to him must be vigorously upheld."[106]

Bellosi's mention of Raphael and especially of Fra Bartolomeo could not be more apt. Just compare the elderly figures – the Joseph of Arimathea and the woman with her hands raised – in Bellini's painting (fig. 54) and one of the black-chalk cartoons by Fra Bartolomeo in the Uffizi (fig. 55), preparatory (and therefore probably done in Venice) for the Saint Catherine of Siena in his 'Venetian' altarpiece, now in the Villa Guinigi (fig. 42).[107]

As mentioned earlier, Berenson grouped the *Lamentation* together with the Dudley Madonna as the work of Rocco Marconi. Despite the change in attribution, the relationship he saw between the two works must be upheld. Although they are so different in subject and in

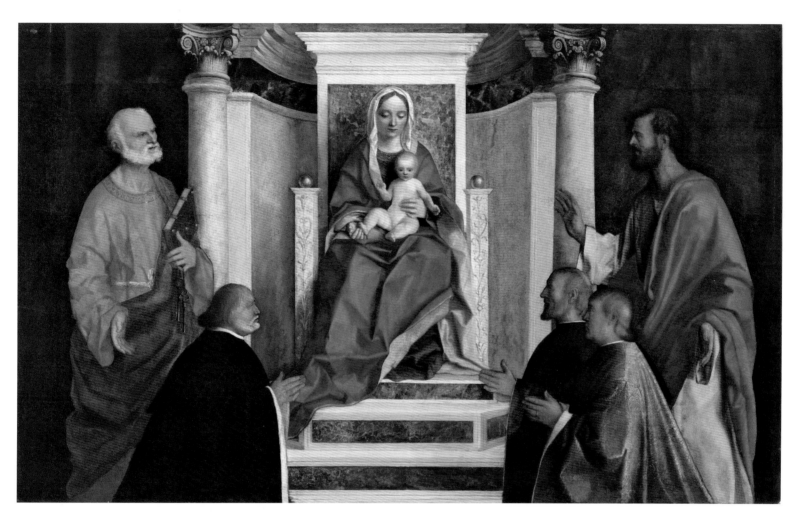

52
WORKSHOP OF
GIOVANNI BELLINI
*The Madonna and Child
enthroned between two saints
and three donors* (The Procuratia
di Ultra Altarpiece), 1510
Baltimore, Walters Art
Museum, inv. no. 37.446

GIOVANNI BELLINI
The Lamentation, c. 1509–11
Venice, Gallerie dell'Accademia,
inv. no. 321

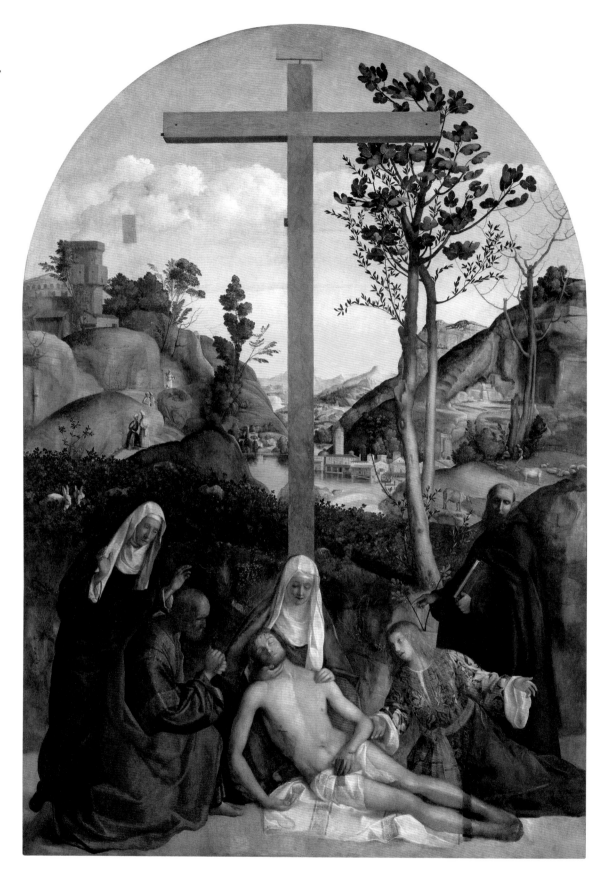

GIOVANNI BELLINI, *CIRCA* 1508

emotional expression, the two works have elements in common, if one takes for example the detail of the Virgin with the dead Christ in her arms (fig. 56). One can see a common formal language, subtle and dense with meaning though expressed in apparently casual details, such as Mary's cherry-red robe that shows through, in a very calculated way, in various areas, of different sizes (even very small, little more than the size of a fingernail), and in various irregular geometric forms – scalene, triangular, rhomboid, even hexagonal.

The *Lamentation* (fig. 53) comes from the church of Santa Maria dei Servi, victim of the Napoleonic suppression and demolished at the start of the nineteenth century. In a study published in 1987, Jacopo Benci and Silvia Stucky persuasively identified the man on the right holding a book, then thought to be Saint Philip Benizzi of the Order of the Servi (Servants of Mary), as Bonaventura Tornielli da Forlì, who, before his death in Udine in 1491, had had very strong connections to the convent of Santa Maria dei Servi.[108] In early 1509, Andrea Loredan (patron of Titian and Sebastiano del Piombo, as noted above), representative of the Republic at Udine, fell gravely ill, but returned to health after having commended his soul to Bonaventura da Forlì. In late February 1509, Loredan, having reached the end of his term of office in Udine, decided to take with him back to Venice Bonaventura's remains, which he laid to rest beneath the main altar of Santa Maria dei Servi. Is it plausible that the commissioning of the altarpiece had to do with this event? Under Andrea Loredan's auspices, did Bellini start the altarpiece in 1509, with the memory of Fra Bartolomeo fresh in his mind? This would partly explain the formal complexity and innovative design of the *Lamentation*, in full dialogue with 'modern' art.

It is not unlikely that Loredan had already patronized Bellini for the decoration of his palace designed by Mauro Codussi, complete by 1509. According to Carlo Ridolfi, writing in 1648, Bellini "painted in the hall of the Grimani palace [Palazzo Loredan] in Santa Ermagora two large Cosmographies with the figures of Ptolemy, Strabo, Pliny and Pomponius Mela, and signed them with his own name".[109] Unfortunately, there is no trace of these paintings, although we can imagine that if they existed they would be the same size as Sebastiano del Piombo's *Judgment of Solomon* and Titian's *Flight into Egypt*, which can be dated to about 1506–07, and which, as mentioned above, come from the same palace (which also contained frescos sometimes attributed to Giorgione, sometimes to Titian).[110] A document of 1581 regarding the Loredan family's sale of the *palazzo* to the Duke of Brunswick refers to "four large paintings existing in the said Palace". Is this a reference to the two canvases by Sebastiano and Titian and the two *Cosmographies* by Bellini?[111] Furthermore, only two years later

54
GIOVANNI BELLINI
The Lamentation, detail of fig. 53

55
FRA BARTOLOMEO
Saint Catherine of Siena, c. 1508
Florence, Uffizi, Gabinetto
Disegni e Stampe, inv. no. 1778E

GIOVANNI BELLINI, *CIRCA* 1508

F. BARTOL. DI S. MARCO F.

85

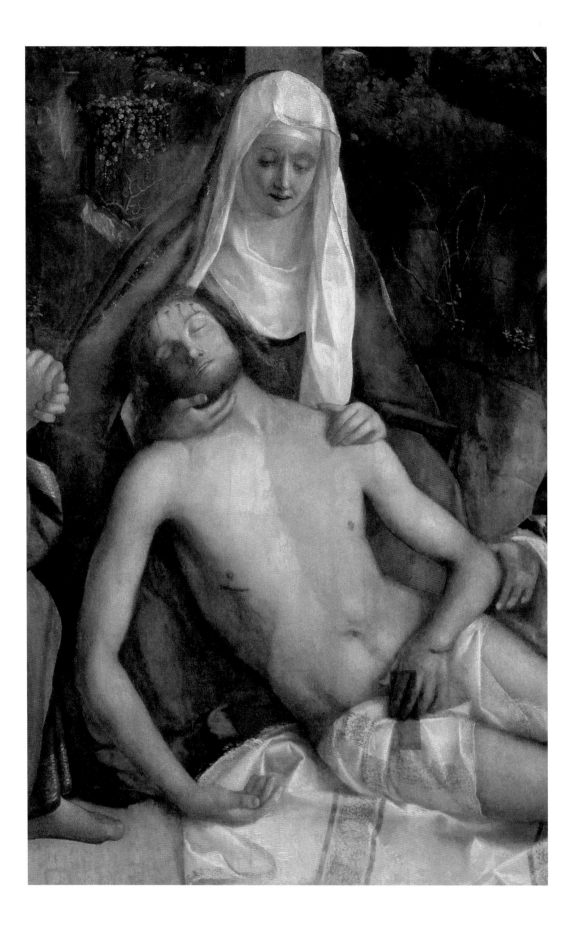

GIOVANNI BELLINI, *CIRCA* 1508

the Palazzo Loredan passed into the hands of Guglielmo Gonzaga, and in the related correspondence it is mentioned that two "paintings are in their usual place"; in another letter there is a specific description: "climbing nineteen steps up the said stairway, there is the very handsome *portego*, where there are the cosmography paintings, one of which shows Italy depicted very skilfully, and the other Africa".[112] In a 1730 inventory of the assets of Francesco di Vincenzo di Giovanni Grimani Calergi, to whom the palace had in the meantime passed, there is notice of "two large pictures with two parts of the world, one of the Sea, and the other of Earth with four chiaroscuro figures, two for each of said pictures" (Bellini's two paintings), and a little further on "two large, oblong pictures, one with Solomon's Judgment and the other with the Virgin Mary going to Egypt, with gilt carved frames" (the two canvases by Sebastiano del Piombo and Titian).[113]

Consideration of these works in the Palazzo Loredan encourages us to reflect that in these years Bellini was in the service of patrons of advanced taste in Venice, especially Andrea Loredan, who also employed his best pupils (or ex-pupils). Bellini's perennial curiosity was excited by a number of stimuli and was encouraged by his patrons' requirement that he should innovate, as we find him doing, perhaps to our surprise, both in the Accademia *Lamentation* and in the Dudley Madonna.

Aglietti's words come to mind: "Inspired by their [Giorgione's and Titian's] bold example and by their success, he gave up his old habits and from being their master he became almost their pupil, as he resolutely set out on the new road".[114] When Giorgione died in 1510 another six years of ceaseless activity remained for Bellini, in "an old age as green as the most beautiful flower of youth, and truly worthy of a god".[115]

1 The presence of Giovanni Bellini's signature is not in itself proof that the painting is autograph. For discussions on this topic, see WALKER 1956, pp. 95-98; CAMPANA 1962, pp. 405-11; PINCUS 2008.

2 See STEINBERG 1983, pp. 15-16.

3 "The flower of the Synagogue withers, and the Church flourishes": LEVI D'ANCONA 1977, pp. 382-83, 387.

4 Luigi Martelli (1804-1853) was an engraver from Faenza, but active mainly in Bologna. For a comprehensive list of his prints, see DAVOLI 2006, pp. 122-25, nos. 20835-20874 (the one after the Dudley Madonna is listed on p. 122, no. 20842, inv. no. 9124).

5 Luigi Salina (1762-1846) was a distinguished intellectual and collector. Some of his papers are kept at the Biblioteca dell'Archiginnasio, Bologna, but none of them refers to his collection.

6 GIORDANI 1830. On the Salina Amorini Bolognini palace see ROVERSI 1994. The Bolognese art historian Gaetano Giordani was very close to Luigi Salina, and he made a valuation of Salina's collection of paintings (Bologna, Biblioteca dell'Archiginnasio, *Manoscritti Giordani, Famiglie Bolognesi - Notizie artistiche ad esse relative*), in which, however, no paintings by Bellini can be found.

7 Luigi Salina's son Camillo (1793-1855) had his first son Francesco in 1826 (with Barbara Bolognini, whom he married the previous year: see ROVERSI 1994, pp. 134-35), and it is not impossible that Martelli's engraving dedicated to Luigi Salina, with the incription *Virgo et Mater*, is related to this event.

8 On the historical figure of John William Ward, see HAMILTON 1921. On his role as collector and on the Dudley collection in general, see PENNY 2008, pp. 452-55.

9 Letter to the Bishop of Llandaff, 29 November 1814: *Letters* 1840, p. 62, no. XII.

10 Ward alludes to a journey to Venice in a letter dated 24 June 1815, sent from Rome to his friend John Benbow, in which he writes that it would soon be possible to contact him "at Siri and Willhalm's, in Venice" (Coseley, Local History Service, Dudley Estate Archive, IV, 14). Siri and Willhalm were Byron's bankers in Venice.

11 AGLIETTI 1815. On Francesco Aglietti as a collector see TOSATO 2002.

12 "*La bellissima tavola della Vergine sedente in mezzo ad amenissimo paese in casa Mocenigo a s. Polo, segnata dell'anno 1509*": AGLIETTI 1815, p. 78. I came across this first mention in print of the Detroit Madonna following a reference in VALENTINER 1928, p. 22. Aglietti's description is followed by another of a mysterious Madonna, impossible to identify: "the one that is no less beautiful, done with such a firm hand and such a vibrant effect that it shines even among the Titians in the Barbarigo Palace" ("*quella non men bella e di tocco sì risoluto e sì forte di macchia, che brilla puranco in mezzo a' Tiziani di casa Barbarigo*"). The Madonna in the Barbarigo collection may in any case correspond to one described in the catalogue of the 1845 collection: BEVILACQUA 1845, p. 11, no. 9.

13 Unfortunately, in the Dudley Estate Archive, preserved at the Dudley Archives and Local History Service in Coseley (West Midlands), there is no significant document concerning the collection of paintings that John William Ward assembled.

14 *Catalogue* 1828, page 13, no. 31. They were exhibited in the "North Room (East Side)" of the British Institution. Bellini's presumed self-portrait (*Catalogue* 1828, p. 13, no. 28) can be identified as lot 43 of the 1892 Dudley sale (*Catalogue* 1892, p. 10, no. 43), sold to Sedelmayer. In lot 46 of the latter sale there is a "Head of a Man" attributed to Giovanni Bellini (*Catalogue* 1892, p. 19, no. 46), which Paul Durand-Ruel purchased on behalf of Martin A. Ryerson. This painting is presently held in the Art Institute of Chicago (Mr and Mrs Martin A. Ryerson collection, inv. no. 1933.1002), and is actually - as WAAGEN 1854 (II, p. 232) had already deduced - a work by Pontormo, depicting Alessandro de' Medici (see LLOYD 1993, pp. 197-202, repr.).

15 Even if in *Art Treasures* 1957, pp. 16-17, no. 58, it is said that the Madonna attributed to Bellini lent by the Earl of Duley in 1828 is the one in question.

16 PASSAVANT 1833, pp. 103-04; see also PASSAVANT 1836, I, pp. 229-31.

17 See Penny's biographical and collecting profile: PENNY 2008, pp. 452-55.

18 We know the date of Waagen's visit from WAAGEN 1854, III, p. 199. Various paintings from the Dudley collection are described in WAAGEN 1838b, II, pp. 397-98. See also the contemporary German edition, WAAGEN 1838a, II, pp. 204-06.

19 WAAGEN 1838b, II, p. 397. The contemporary German edition reads as follows: "*Giovanni Bellini. Maria mit dem Kinde in einer Landschaft hat nicht allein seine Milde und Ruhe in dem religiösen Gefühle, sondern ist von besonderer Klarheit der Farbe, und ungewöhnlicher Zierlichkeit in den Händen der Maria. Es trägt den Namen des Künstlers*" (WAAGEN 1838a, II, p. 204).

20 WAAGEN 1838b, II, p. 397; WAAGEN 1838a, II, pp. 204-05. The title of this work comes from the inscription that runs on the parapet, *Jacobus Cambarus Bonon. per Franciam Aurifabrum hoc opus fieri curavit 1495*, which provides the name of the patron, Jacopo dal Gambaro: AGOSTI 1998, p. 63, note 63.

21 On the provenance of the Gambaro Madonna, see NEGRO AND ROIO 1998, pp. 164-65, no. 35b. One of the most comprehensive sources of information on private collections at the end of the eighteenth century in Bologna is provided by Marcello Oretti. He mentions a "*Beata Vergine col Bambino. Assa*" (Holy Madonna and Child, in vertical format) by Giovanni Bellini in the Aldrovandi palace in Strada Galliera (see CALBI AND SCAGLIETTI KELESCIAN 1984, p. 37). In the Aldrovandi papers (Bologna, Archivio di Stato, Archivio Aldrovandi-Marescotti, b. 284), there are records of a dispute continuing from 1719 to 1724 about the authenticity of a lot of pictures sold by the 'Abate' Salvatore Maria Rangoni from Modena to Nicolò Aldrovandi. Among them, there is "*Una Madonna sulla Tavola col Bambino in braccio, e v'è un Paese ... le Figure a mezze Figure del naturale*" ("A Madonna carrying the Child, on panel, with a landscape background ... the figures are half life-size"). This is fascinating, but since the subject of the Madonna and Child by Bellini is very common in inventories, it is impossible to prove which particular picture this is. Another interesting element is a document (Bologna, Archivio di Stato, Archivio Salina Amorini Bolognini, b. 464) stating

that in 1822 "*M.sa Marescotti in casa Rusconi mise fuori molti bei quadretti*" ("The Marchesa Marescotti who lives in the Rusconi Palace had displayed outside many fine pictures"), the Marescotti being closely related to the Aldrovandi. Among the paintings on display were a Giovanni Bellini, a Cima da Conegliano and a Francia.

22 PENNY 2008, p. 453.

23 "*Dall'Italia uscendo e trasportandoci in altre regioni, faremo menzione in prima di quelle pitture di Giovanni che si trovano in Inghilterra. La raccolta di Lord Budley [sic] ha una Madonna col Bambino, segnata del nome di questo pittore. Opera, che alla dolcezza e alla pace del sentimento religioso, congiunge una particolar trasparenza di colore e una vaghezza rara nelle mani della Vergine. La quadreria del signor Beckford possiede il ritratto di profilo del doge Vendramin, segnato del nome di Giovanni e dell'anno, che, per quanto il quadro sia collocato molto alto, sembra essere il 1476. Come pure il ritratto di un altro Doge, veduto di faccia, colla scritta: Ioannes Bellinvs*": MARCHESE et al. 1849, p. 25.

24 The fact that John William Ward knew William Beckford is clear from a letter to Edwin Landseer dated 15 December 1827 (Victoria and Albert, National Art Library, inv. no. MSL/1962/1316/101).

25 PENNY 2008, p. 453. See also reviews of the exhibition, such as H.W. 1851, p. 723. Bellini's *Madonna* does not seem to be mentioned in this review, in which no more is said about the Ward paintings attributed to the Venetian painter than: "To the latter [Bellini] is attributed a 'Holy Family': - a composition after the ordering of his day. The picture we think too cold in its general hue, and too deficient in breadth, for the master. The small portrait of a man habited in black may better be credited as his". This last mentioned work must be the portrait by Pontormo, cited in note 14.

26 For the utterly convincing attribution to Donatello, see F. Caglioti, in *Il Giardino* 1992, pp. 72-78, no. 14.

27 Venice, Biblioteca Marciana, Fondo Cavalcaselle, It. IV. 2037 (=12278), Taccuino VII, ff. 1v-15r. For the date of this visit, see MORETTI 1973, pp. 105-08; LEVI 1988, p. 34; for another visit that happened in March 1856, see *ibid.*, p. 64; Eastlake is mentioned in a note in one of the sketches.

28 "*Senza la segnatura io l'avrei preso come quadro della scuola dei Bellini - I / paese bello / se il nome è vero è copiato / Sta segnato sulla pittura / IOANNES BELLINVS nome sospetto, o copiato / del terzo Bellini ? vedi Vasari*" (I am grateful to Susy Marcon of the Biblioteca Marciana for her help in this transcription).

29 Venice, Biblioteca Marciana, Fondo Cavalcaselle, It. V. 2033 (=12274), Fascicolo XX, ff. 51r-56v.

30 "*rossastro IOANNES BELLINVS / tavola Bellini / siccome quel nome è aggiunto / coprendo o se antico fu ritocco, ed anche antico / fu fatto dal copista copiando un / bellini - quadro di un aspetto più / moderno - copia antica piacevole / quadro piacevole ma della scuola / del genere del Bissolo ma più fermo / (più vuoto di certi quadri di di Rondinelli / nel modo di B)*" (I am grateful to Susy Marcon of the Biblioteca Marciana for her help in this transcription).

31 CROWE AND CAVALCASELLE 1871, I, p. 190, note 8, and p. 592, note 8.

32 *Exhibition* 1871, p. 29, no. 315.

33 Published in part by PEARCE 1986, p. 133, fig. 99; and PENNY 2008, p. 453, fig. 5.

34 NEGRO AND ROIO 1998, pp. 178–79, no. 54, fig. 54.

35 Other works on the wall (see fig. 10) can be recognized: in the top row, note, at the centre, Carlo Crivelli's *Deposition* (today in Detroit, Institute of Arts, inv. no. 25.35), hung between two fragments of Correggio's lost *Coronation of the Virgin* fresco from the church of San Giovanni Evangelista, Parma (today in the National Gallery, London, inv. nos. NG 4067 and NG 3920). In the second row from the top, on the left, a composition after Bernardino Luini showing *Modesty and Vanity*, known only from copies or derivations.

36 Note also that the frame is the same one that is in place today. On the back is a card (probably twentieth-century) bearing the name of the Carousel company, a frame-manufacturing, restoring and gilding firm that was based in Salisbury.

37 *Catalogue* 1892, p. 19, no. 45 (copy annotated with prices and purchasers in the library of the National Gallery in London).

38 See the reviews of the show that appeared in Germany and in Italy (SEIDLITZ 1895 and FFOULKES 1895), which are rather more like reviews of Berenson's work.

39 BERENSON 1895, p. 24; BERENSON 1901, p. 121.

40 See BERENSON 1899.

41 BERENSON 1895, pp. 28–29.

42 The Ottawa *Standing Christ* is discussed, and believed to be an autograph work of Bellini's of no later than 1505, by PALLUCCHINI 1959, pp. 98–100, 153, fig. 193, and also by BERENSON 1957, I, p. 33. The Ottawa *Christ* is the usual *pastiche* – however high in quality – of Bellini's motifs: the city in the background is, in fact, taken from the *Madonna of the Meadow* in the National Gallery of London (inv. no. NG 599).

43 "At this time, as [Bellini] was already old, he let his pupils work a great deal on his paintings. Proof is in the Galleria di Brera Madonna and the Düsseldorf Academy triptych, recently attributed to the pseudo-Basaiti, and which, instead, were in all likelihood done under the direct supervision of the master, with the collaboration primarily of Rocco Marconi, judging from his signed Madonna, conserved at Strasbourg gallery, and which has many points in common with the Brera Madonna" ("*In questo periodo, essendo* [Bellini] *già vecchio, egli lasciò molto lavorare gli scolari nelle opere proprie. Ne sono prova la Madonna della Galleria di Brera e il trittico dell'Accademia di Düsseldorf, attribuiti recentemente al pseudo-Basaiti, e che invece possono ritenersi eseguiti sotto la direzione immediata del maestro, con la collaborazione principale di Rocco Marconi, a giudicare almeno dalla Madonna firmata da questo, conservata nella Galleria di Strassburg, la quale ha molti riscontri con la Madonna di Brera*"): VENTURI 1907, p. 389.

44 The Metropolitan *Madonna and Child* was sold at Sotheby's, London, 7 December 1927, lot 44 (as by Cima da Conegliano). As noted elsewhere several times, the city in the background of the Metropolitan painting is taken from the London National Gallery's *Madonna of the Meadow* – a case similar to that of the Ottawa *Christ* (see note 42).

45 "*... questo getto sì ben calcolato dei drappi: egli ha una gran passione di muover le pieghe nobilmente e di disporne i piani, le svoltate ... le opposizioni ... con sottil senso di logica*": CANTALAMESSA 1907, p. 16.

46 The attribution of this work to Vincenzo Catena, proposed by GUIDONI 1999, p. 31, is as curious as it is unsustainable.

47 CANTALAMESSA 1908. The location of this version at Luigi Bellini's can be deduced from the inscription on the back of a Reali photograph dating to *c.* 1900–05, kept in the photographic archive of the at the Kunsthistorisches Institut in Florence (inv. no. 20107). The fact that Gronau saw it when it was owned by Elia Volpi can be deduced from GRONAU 1928, pp. 12, 34, note 6; GRONAU 1928–29, p. 62, note 1.

48 "*Similissimo nella composizione a quella di S. Maria in Trastevere, e tratto con palese intendimento di pia imitazione dello stile di Giovanni Bellini, ci guida agevolmente a pensare che un originale dello stesso Bellini ci sia stato, da cui tutti e due i quadretti sono partiti; e non sarebbe da meravigliarsi che qualche altro ne sbucasse fuori*": CANTALAMESSA 1908, p. 105.

49 "*Ogni curiosità impaziente qui si doma, soggiogata da un più puro e alto sentimento penetrato nell'anima, cioè dalla speranza che possa quandochessia esser discoperto l'originale stesso che intravediamo a traverso di queste copie, un'altra opera ove si sia effuso quel grande spirito che onorò Venezia. Se non è audace osar d'indovinare da questi scarsi elementi a che punto della vita egli fosse pervenuto, allorché disegnava questo bel gruppo, io dico ch'egli era al primo decennio del cinquecento, quando nel mirabile vecchio si compieva il miracolo di una più alta ascensione in onta agli anni; e certo chi può immaginar questa composizione adorna della grazia raffinata e delle floridezze belliniane, vede con la fantasia un rarissimo gioiello d'arte*": ibid., p. 106.

50 In 1911 a version of this composition (Appendix II, copy C), bearing a weird and certainly fake signature in italic *Iohannes Bellinus*, was exhibited as attributed to Giovanni Bellini at the enormous '*Mostre retrospettive*' in Rome, Castel Sant'Angelo. The exhibition catalogue (*Guida generale* 1911, pp. 137–38, illus. p. 137) reports its ownership as "*Sig.a Nella Bolognesi*", but on the back of a photograph (in fact of copy A) kept in Florence (Kunsthistorisches Institut, inv. no. 424782) the ownership is described as "*Prof. Nello Bolognesi*".

51 "*Un'altra composizione bellinesca, che ha indubbi rapporti con l'Urbinate, è la Madonna ... pure della collezione Duveen da me veduta molti anni fa presso Carlo Loeser. Il Bambino ricorda quelli del 1505–6 mentre la Madre col suo atteggiamento leggermente abbandonato e ondulato sembra concepita sotto l'impressione di qualche figura raffaellesca, ma radicalmente mutata poi negli effetti pittorici, a causa delle marcate spezzature e lumeggiature del drappeggiamento. Il fondo del paese presenta pure elementi bellineschi*": GAMBA 1937, pp. 175–76, 194, unnumbered fig. Regarding the Raphael connection, it is interesting to mention that on the back of the Reali photograph of copy B (Florence, Kunsthistorisches Institut, inv. no. 20107), there is the inscription "*Scuola di Raffaello*". Curiously, a similar inscription ("*Scuola Raffaellesca*") appears on the back of a photograph of copy E (New York, Frick Art Reference Library, inv. no. 10945).

52 The painting has undergone a heavy conservation treatment, as can be deduced by a photograph of around 1982 that shows it after cleaning and before restoration (New York, Frick Art Reference Library, inv. no. 243201).

53 Duveen Brothers Records, 1876–1981, bulk 1909–64, accession number 960015. I am indebted to the librarians of the Getty Institute for their professionalism and having so promptly and generously provided me digital access to these materials. The engraving appears in REINACH 1910, p. 427, fig. 1. In the photographic archive of the art dealer and restorer Enos Malagutti, now owned by Luigi Koelliker in Milan, there is – in the Giovanni Bellini files – a photograph of the painting held by the Norton Simon Museum, with on the back a typewritten expertise, with complete bibliography. The same expertise is attached to the back of a photograph kept in the Kunsthistorisches Institut in Florence (inv. no. 424780).

54 After all, Berenson had included in his 1957 lists even copy A under Bellini's name. In the Bellini files held by the Giuseppe Fiocco photographic archives, at the Fondazione Cini in Venice, there is a photograph (inv. no. 3786) of a modest copy of the Dudley Madonna (Appendix II, copy D), but with interesting variations, both in the format and in the presence of the drapery behind Mary. It does not look too far from certain reproductions of Bellini's works by the prolific and serial output of the Santacroce workshop (a group of painters from the Bergamo area still active in the Veneto in the mid sixteenth century). This Madonna was sold at Sotheby's as "School of Giovanni Bellini".

55 "*L'atteggiamento scorciato e controbilanciato alla fiorentina del Santo domenicano*": GAMBA 1937, p. 176.

56 GRONAU 1928. In the same years, another fundamental addition (the *Noah* at Besançon, Musée des Beaux-Arts, inv. no. 896.1.13) to Bellini's late work came from Roberto Longhi: LONGHI 1927, p. 182; for Bellini's late career in general, see also LONGHI 1949, pp. 107–09; ROBERTSON 1968, pp. 109–54.

57 LUDWIG AND BODE 1903, p. 41.

58 Gronau later discussed the Santa Maria in Trastevere Madonna (Appendix II, copy A) and the one today at the Norton Simon Museum (Appendix II, copy B) in his 1930 monograph, comparing them to the Northbrook Madonna (fig. 12): "*Aus S. Maria in Trastevere, Rom, nicht, wie ich nach L'Arte XIV (1911),* [p.] *480 annahm, bei einem Brande zugrunde gegangen, doch schwer beschädigt. Ein zweites etwa gleichwertiges Exemplar war früher bei Ch. Loeser, Florenz (jetzt Sir J. Duveen, New York). Vgl. die rechte Hand Mariens mit der Madonna ehem. Northbrook (S. 157)*": GRONAU 1930, p. 158, fig., p. 215, no. 158.

59 WATERHOUSE 1955, p. 295; Pallucchini's original text reads: "*Dopo il 1510 è certo la monumentale Madonna che tiene il Bambino sulle ginocchia, seduta su di uno sfondo di paesaggio con alberi ad alto fusto, della collezione inglese Niel Rimington ... caratterizzata dalla complessità dei panneggi intrisi di luce. Si direbbe che il Bellini abbia sentito il fascino di Raffaello: una grandiosità di ritmi ed al tempo stesso una sottigliezza classicistica filtrata anche nelle espressioni dei sentimenti*": PALLUCCHINI 1959, pp. 106, 155, fig. 211.

60 GIBBONS 1962a, p. 128.

61 A reproduction of the pre-restoration appearance of the work in 1965 may be found in BENCI AND STUCKY 1987, p. 48, fig. 1.

62 It bears comparison with other portraits by Previtali (such as the one in the Poldi Pezzoli, Milan, inv. no. 1598, or the one auctioned by Christie's in London on 11 December 1992, lot 6: MAZZOTTA 2009a, pp. 11–12, 56–57, pl. III-V).

63 "E fu appunto in quest'epoca, la quale segna della più gloriosa nota nei fasti della Veneta Pittura gli anni 1506 e 1507, che io credo doversi collocare quella meravigliosa risoluzione che trasse Giovanni dal più elevato poggio della sua gloria a farsi seguace ed imitatore dei discepoli, e ad emularne con nuovo ardore i successi": AGLIETTI 1815, p. 73.

64 On the first signs of Giorgione's influence on Bellini's work, see, most recently, MAZZOTTA 2009b.

65 Giovanni Bellini's little Saint Jerome (National Gallery of Art, Washington, inv. no. 1939.1.217) is also dated 1505.

66 AGOSTI 2009, pp. 126–27. To get an idea of the great critical ill fortune that has struck this painting, it is enough to cite Felton Gibbons's attribution of it to the mediocre (at best) Marco Bello: GIBBONS 1962b, pp. 46–47.

67 William Paulet Carey's sale, at William Hazard, 25 October 1814, lot 37 (consulted through the Getty Provenance Index Database). For a critical and collecting history of the altarpiece, see the fine study CANNON-BROOKES 1977.

68 It is attributed to Giovanni Bellini, and dated around the same time as the Santa Corona Baptism, by BALLARIN 1968, pp. 241–42, fig. 316. In the museum's catalogue it is ascribed to "Giovanni Bellini and workshop": SKUBISZEWSKA 1995, pp. 44–46, no. 4 (whose fine entry should be supplemented with, under 'Provenance', the ownership of Victor Rheins, Berlin, who believed it to be the work of Marco Basaiti, a fact that can be deduced from a clipping once pasted to the back of the panel and now in the museum files, kindly shown to me by Piotr Michałowski, whom I thank. Also on the back of the panel is an inscription made with a paintbrush, perhaps dating from the nineteenth century, that refers to Cima da Conegliano). See also TEMPESTINI 2009, pp. 47, 50, fig. 43.

69 As supposed also by HEINEMANN 1962, I, p. 28, no. 107; BALLARIN 1968, p. 242.

70 In the literature, as far as I know, it has been associated with Previtali only by WAAGEN 1838a, II, p. 328; WAAGEN 1838b, III, p. 118.

71 For the reason that 1501 is the date of the Denver Saint Dominic (made for Alfonso d'Este), extremely similar to the Accademia picture: see MAZZOTTA 2009b, p. 7, fig. 9, pp. 15, 24, note 71.

72 To this phase is supposed to belong the Madonna and Child with a donor in the Alana collection (see MINARDI 2010 and M. Minardi, in BOSKOVITS 2011, pp. 64–70, no. 10), which, however, is not at all as exciting as Bellini's undisputed work of that period.

73 For the original text of the letter see RUPPRICH 1956, pp. 43–44, no. 2 (and see also FARA 2007, pp. 32–33). For Bellini's friendship with Dürer, see FARA 1997.

74 "Nella maniera de' panni mostri un certo che di tagliente, secondo la maniera tedesca; ma non è gran fatto, perchè imitò una tavola di Alberto Duro fiammingo, che di que' giorni era stata condotta a Venezia e posta nella chiesa di San Bartolommeo, che è cosa rara e piena di molte belle figure fatte a olio": VASARI 1550 AND 1568, VI, p. 158.

75 This is known thanks to the description of the Bembo collection by Marcantonio Michiel: MICHIEL 1521-43, p. 20. On the relationship across generations between the Bembo and Bellini families see FLETCHER 2004, pp. 30-31.

76 "tanta battaglia che 'l castello al tutto credo si renderà": BARAUSSE 2008, p. 351, no. 93.

77 On the correspondence concerning the Nativity for Isabella d'Este see FLETCHER 1971. For a very plausible identification of the Nativity (from a stylistic point of view, as well: the landscape is identical to the one in the Santa Corona Baptism dated around 1501) as the Uffizi's Sacred Allegory (inv. no. 903): AGOSTI 2009, pp. 145–47, 189–90, notes 81–89.

78 "Il carico de far la inventione poetica": BARAUSSE 2008, p. 351, no. 94.

79 For the dating see A. Ballarin, in Le Siècle de Titien 1993, pp. 337–41, no. 28.

80 "La forza e la sublime sprezzatura di Giorgio perfettamente accoppiate alla morbidezza e alla verità di Tiziano, e impreziosite di tutta la grazia e venustà Belliniana, irraggiano questo quadro di tanta luce": AGLIETTI 1815, p. 77.

81 On the subject of Titian's debut see MAZZOTTA 2012, with further references.

82 Titian's Flight into Egypt in the Hermitage (for its history and critical fortune: ARTEMIEVA 2012), as well as Bellini's Assassination of Saint Peter Martyr, were on display from 4 April to 19 August 2012 at the National Gallery in London: MAZZOTTA 2012.

83 Note the curious coincidence of some of the details in the landscape of the Assassination of Saint Peter Martyr (fig. 31) and the so-called Pietro Bembo in the Royal Collection (fig. 30), already pointed out in MAZZOTTA 2009b, pp. 17, 20, figs. 24-25.

84 A plausible vehicle for the spread of the Laocoön's fame to Venice was Cardinal Domenico Grimani, who resided in Palazzo Venezia (then Palazzo di San Marco) in Rome from 1505, and who, according to Vasari, owned a small bronze copy of it, made by Jacopo Sansovino: AGOSTI AND FARINELLA 1987, pp. 54-57.

85 The painter Morto da Feltre, who returned to Venice in 1507 after his experiences in Rome at the close of the Quattrocento and in Florence at the start of the Cinquecento, has been indicated as possibly responsible for the circulation in Venice of Michelangelo's cartoon: BALLARIN 1981, p. 27.

There is a practically literal citation from the Battle of Cascina in Titian's engraving of the Triumph of Faith (as pointed out by HOPE 1980, pp. 14-15, figs. 3-4), datable to 1508 both stylistically and by derivations themselves datable with fair precision – and, furthermore, Vasari confirms it – about which see, most recently, AGOSTI 2005, p. 99, note 44 (although many still believe the date should be later: for example BURY 1989; JOANNIDES 2001, pp. 269-78). A further element for the dating to 1508 of Titian's print is the exact citation of the St Lawrence in a black-chalk and brown-wash drawing of Saint Helena between Saints Lawrence and Dominic at the Pierpont Morgan Library in New York (inv. no. I, 53),

where it is believed to be "Anonymous, Venetian School, late 15th cent.". It seems to me to be very close to Carpaccio, and not so far from (certainly not later than) a date around 1510. The saint on the right reappears in a drawing attributed to Carpaccio at the Louvre (Département des Arts graphiques, inv. no. RF 437, recto).

86 In fact, on 25 June 1501, Michele Vianello wrote to Isabella d'Este that Bellini would have been "reluctant" to paint the "storia" that the Marchesa had requested "because he knows your ladyship's acumen that would then leap to a comparison with the works of Maestro Andrea": BARAUSSE 2008, p. 345, no. 64.

87 On the citation from antiquity, see TRESIDDER 1992. The decoration for Francesco Corner's cabinet perhaps called for more than two canvases, as is suggested by Giovanni Bellini's two wonderful drawings, which are clearly related – not only stylistically but also in terms of scale and dimensions – to the Washington frieze (one is preserved in Paris, Fondation Custodia, inv. no. 4145: A. Mazzotta, in Mantegna 2008, pp. 324-25, no. 133; and the other is in the collections of the Archbishop of Olomouc in Kroměříž, inv. no. KE 4553: M. Togner, in Italian Renaissance 1997, pp. 65-67, no. V).

88 About this, it should be mentioned that Francesco AGLIETTI (1815, p. 78), after the description of the Detroit Madonna (fig. 48) and of the mysterious one in the Barbarigo residence already mentioned at the start of this essay, tells of a "divine head of the Redeemer repeated from the painting of the Supper at Emmaus, and raised up with the most loving labour to the height of any excellent work by the great Raphael" ("divina testa del redentore ripetuta dal quadro della Cena in Emmaus, e sollevata con più amoroso lavoro fino all'altezza di qualsivoglia egregia opera del grande Urbinate"), the location of which, however, is not given. It has occurred to me that it could be the worn but very charming Head of Christ in the National Gallery of Ottawa (inv. no. 4421).

89 Gentile asked his brother to complete his unfinished works in exchange for their father Jacopo's album of drawings, today at the British Museum. Giovanni accepted the task on 7 March 1507: BARAUSSE 2008, p. 354, nos. 105-06. Giovanni's hand can be identified in many of the fine portraits that characterize the public in the foreground: M.T. Donati, in Pinacoteca 1990, pp. 42-52, no. 20.

Another work dated 1507 is the unfathomable (because in very bad condition) panel with Doge Leonardo Loredan with four relations in the Berlin Gemäldegalerie (inv. no. B. 79).

In September 1507 Bellini was commissioned by the Council of Ten to complete three canvases (two of which had already been started by Alvise Vivarini, who had just died) for the Hall of the Great Council in the Ducal Palace (unfortunately lost in the fire of 1577): BARAUSSE 2008, pp. 354-55, no. 107.

Again in 1507 (1 December) the Priuli family commissioned from Giovanni Bellini a triptych, formerly in the church of San Michele in Isola and today in Museum Kunstpalast, Düsseldorf, on permanent loan from the Kunstakademie Düsseldorf (inv. no. M2310); see LUDWIG AND BODE 1903 and especially FLETCHER AND MUELLER 2005. For the Priuli triptych, it is clear that Bellini resorted to his

workshop. It seems to have been laid out nearly immediately after it was commissioned, since the figures are very similar to those in the Washington *Continence of Scipio* (figs. 34-35) in terms of their proportions, with small heads and voluminous clothing. The execution, instead, seems to date from the years 1511-13. There is a fascinating drawing connected with the saints of the right-hand panel of the Priuli triptych in the Albertina in Vienna (inv. no. 2577) bearing the equally fascinating inscription *Bramantino Milanese*: AGOSTI 2009, p. 179, note 48. It certainly is not a copy from the painting, since the donor does not appear, and thus it is either an autograph drawing or a copy from a preparatory drawing by Giovanni Bellini, now lost. It is hard to believe, given its rather high quality, that it is the work of Vittore Belliniano (as proposed in REARICK 1998, pp. 53, 59-60, note 17, fig. 4).

90 See VASARI 1550 AND 1568, IV, p. 163.

91 WILDE 1974, pp. 109-12.

92 "*Lo schema frontale e simmetrico già si articola su piani diversi di profondità e il primo piano è tenuto dalle masse triangolari*": BALLARIN 1965, unnumbered. See also LONGHI 1928, pp. 283-84.

93 See DE MARCHI 1986, pp. 20-21; BALLARIN 1994, fig. 234; BALLARIN 1995, p. 294, no. 331.

94 BARAUSSE 2008, p. 355, no. 108. Carpaccio's and Vittore Belliniano's contribution to the Palazzo Ducale canvases is known through the document mentioned in note 89 above.

Among the several works by Bellini's followers (apart from the copies) that seem to take their inspiration from the Dudley Madonna, it is interesting to note Vittore Belliniano's *Madonna and Child between Saint John the Baptist and Saint Elizabeth* now in the Museo Civico in Feltre (inv. no. 679).

Carpaccio, too, seems to have known rather early on about some of Raphael's prototypes. As Giovanni Agosti has suggested to me, this hypothesis is demonstrated by a 'derivation' from Raphael in the altarpiece of *Saint Vitale on horseback with eight saints*, today in San Vidal in Venice, in which the Virgin and Child that appear among the clouds faithfully reproduce a composition by Raphael known through derivations (one in the Louvre, inv. no. 6794r; and another in Hamburg, Kunsthalle, inv. no. 21417). This topic deserves further study.

Another artist of fifteenth-century training who became infatuated with Raphael is Vincenzo Catena, and he showed it in at least one work, of which two versions are known: one is the *Holy Family with Saint Anne* now in the Gemäldegalerie in Dresden (inv. no. 65). The source is a composition by Raphael known through *bottega* drawings, of which one copy atttributed to Giulio Romano is in Chatsworth (inv. no. 90): ROBERTSON 1954, pp. 30-33, 56-58, nos. 32-33, pls. 26-27.

95 About this commission, see HUMFREY 1990.

96 See, for example, FISCHER 1994, pp. 88-91, nos. 52-53; FRANKLIN 2001, pp. 86-88, fig. 62. The old inscription *Giorgion* on a drawing by Fra Bartolomeo that was probably executed in 1508 (*The Virgin standing*, Paris, Musée du Louvre, Département des Arts graphiques, inv. no. 223: FISCHER 1994, p. 74, no. 40) might also be interpreted in the light of his relationship with Venetian art of that particular moment.

97 Bellini had several commissions from the Dominicans, and there are also portraits, such as the *Portrait of a Dominican with the Attributes of Saint Peter Martyr* in the National Gallery, London, inv. no. NG 808 (but the attributes are a later addition), and the *Portrait of Fra Teodoro of Urbino as Saint Dominic*, dated 1515, also at the National Gallery (inv. no. NG 1440).

98 [F. Russell], in *Old Master* 2010, pp. 100-03, no. 36.

99 On the Louvre drawing and its Venetian air see FISCHER 1994, pp. 88-89, no. 52.

100 WILDE 1974, pp. 112-15.

101 AGOSTI 2009, pp. 151-52, 192, notes 99-100.

102 An attribution to the young Titian and the dating to around 1509-10 has been convincingly proposed in BALLARIN 1994, fig. 231. For this drawing, a very good comparison, in terms of its compositional scheme, is Fra Bartolomeo's drawing with a *Madonna and Child enthroned with saints and a musician angel* (Paris, Musée du Louvre, Département des Arts graphiques, inv. no. 221, recto), executed around 1508-10: FISCHER 1994, pp. 90-91, no. 53r.

103 See, most recently (with an unsustainable stylistic comparison with the Brera Madonna, fig. 50), G.C.F. Villa, in *Giovanni Bellini* 2008, pp. 314-17, no. 60.

104 *Ibid.*, pp. 318-19, no. 61.

105 The design of the Madonna and Child in the Procuratia di Ultra altarpiece has often, and rightly, been associated with that of the Galleria Borghese Madonna (fig. 51). However, there are details, like the Virgin's hand enclosing Christ's foot or the frontal pose of his perfectly round head, that are much closer to the Dudley Madonna.

106 "*Le figure si dispongono con grande agio, respirano liberamente nell'atmosfera circolante ed esprimono un dolore pacato e sublime. Le loro larghe masse possiedono un senso di monumentalità che non ha bisogno di esibizioni. Viene da chiedersi se non ci sia stata una certa consentaneità con Fra Bartolomeo, che fu a Venezia nel 1508. Penso soprattutto al capolavoro assoluto del frate fiorentino che è il Padre Eterno e le Sante Maria Maddalena e Caterina da Siena della Pinacoteca di Villa Guinigi a Lucca. Ma ancora di più sembra di essere in linea con i vasti pensieri di Raffaello al tempo della Disputa del Sacramento. Il Compianto sul Cristo morto che stiamo esaminando è certamente un'opera tarda di Giovanni Bellini e l'attribuzione a lui stesso va fortemente rivendicata.*" This passage by Luciano Bellosi is taken from a paper given at a memorable conference entitled *Grandezza e precocità di Giovanni Bellini* (Giovanni Bellini's greatness and precocity), and delivered on several occasions, of which the last was in Bergamo on 14 April 2011. It is to be published soon in its entirety in the periodical *Prospettiva*.

107 For both the preparatory cartoons see FISCHER 1986, pp. 86-88, nos. 42, 43.

108 BENCI AND STUCKY 1987.

109 "*In casa Grimana a Santa Ermagora dipinse nella Sala due grandi quadri di Cosmografia con le figure di Tolomeo, Strabone, Plinio e Pomponio Mella, e v'iscrisse il nome suo*": RIDOLFI 1648, p. 72.

110 On Andrea Loredan as a patron of the arts there is as yet no dedicated study. For the time being, see, for Sebastiano del Piombo, HIRST 1981, pp. 12-23; for Titian, ARTEMIEVA 2005; the Palazzo Loredan frescos are discussed (as by Titian) by JOANNIDES 2001, pp. 126-27, fig. 111, p. 316, notes 16-20 (with

previous bibliography). Jennifer Fletcher gave a comprehensive and vivid lecture (which hopefully will be published soon) on Andrea Loredan on 23 June 2012 at the National Gallery, London.

111 "*Quattro quadri grandi esistenti nel detto Pallazzo [sic]*": this hypothesis was rightly proposed by Roberta Martinis, who was the first to publish the document: MARTINIS 2000, pp. 27-30, 35, notes 88-91, pp. 36-37.

112 "*Ascendendo per la detta scala gradi diecenove a trovare il bellissimo portico, dove sono i quadri di cosmografia, in uno de' quali si vede con molt'artificio depinta l'Italia et nell'altro l'Africa*": SOGLIANI 2002, p. 329, no. 581, pp. 330-31, no. 584 (I am grateful to Jennifer Fletcher for pointing out this reference to me).

113 "*Due quadri grandi con due parte di mondo, una di Mare, e l'altra di Terra con quattro figure di chiaro scuro due per parte di detti Quadri*"; "*due Quadri grandi bislonghi uno col Giudicio di Salamon, e l'altro con Maria Vergine che và in Egito con soaze d'Intaglio dorate*" (Venice, Archivio di Stato, Notarile, Atti, b. 7131, ff. 291-315v: consulted thorough the Getty Provenance Index Database). On further inventories, and on the destiny of the collection see CECCHINI 2007.

114 "*Preso ardimento dal loro [Giorgione and Titian] esempio e dai loro successi, rinunciate le antiche abitudini e fattosi quasi di maestro discepolo, slanciossi risoluto nella nuova strada*": AGLIETTI 1815, p. 48.

115 "*Vecchiezza tutta verdeggiante del più bel fiore della gioventù, e degna veramente d'un dio*": AGLIETTI 1815, p. 78, speaking of Bellini's altarpiece at San Giovanni Crisostomo, dated 1513. On the inventory of the few assets found in Giorgione's home after his death, a recent discovery, see SEGRE 2011. We might say that 1510 is the year of the emancipation of Bellini's other two finest pupils: Titian undertook the cycle of frescos for the Scuola del Santo in Padua, his manifesto of maturity; Sebastiano del Piombo was preparing to depart for Rome, effectively for good.

APPENDIX I

Technical Images

The Madonna and Child under examination here is not in a perfect state of
conservation (it is painted on a panel made from a single piece of wood that
today is warped, though in an even manner). The most recent conservation
treatment took place after 1955, when the painting was shown at the
Exhibition of Italian Art held at the Birmingham Museum and Art Gallery,
and the photograph taken at the time (fig. III; see also fig. 3) presents a
different appearance: it was still 'clogged' by overpainting, surely done
before the beginning of the nineteenth century (see pp. 17–18 and fig. 2).
In 2012 Ingeborg De Jongh undertook a very light campaign of (reversible)
retouching, after which new photographs were taken (they are employed in
this book). For an image of the painting before the retouching, see fig. IV.

If one compares the appearance of the painting before and after the late
1950s removal of the retouchings several differences become obvious: ob-
serve, for example, the faces, clearly, if only slightly, different from today.
Or the Child's hair, in which formerly each lock was distinct (fig. II), and
today is more woolly (fig. I). Above all, the tree on the left, formerly lush
with foliage, is today bare of leaves, according to the artist's original concep-
tion. Using the photographic techniques available today (see figs. V–VII; the
photographs were taken at the Art Access & Research laboratory in London),
we can form a good idea of its state of preservation.

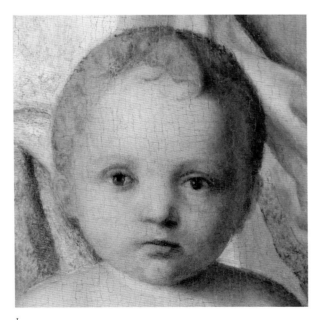

I

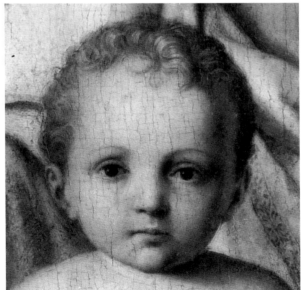

II

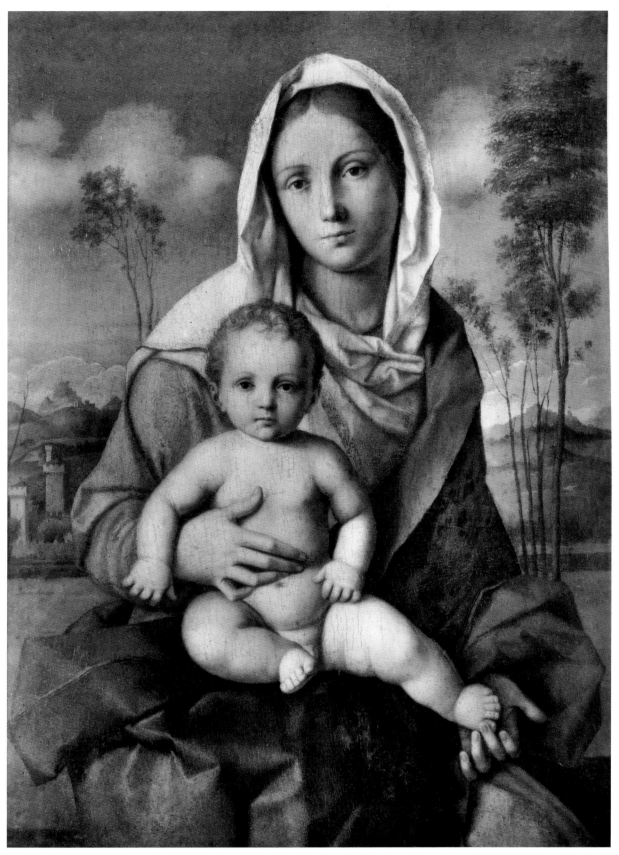

III

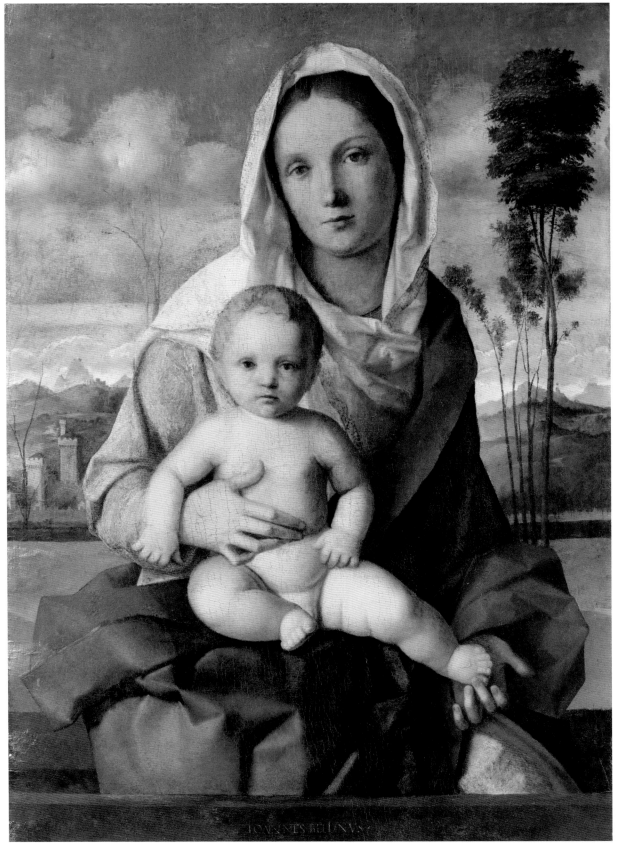

IV

APPENDIX I

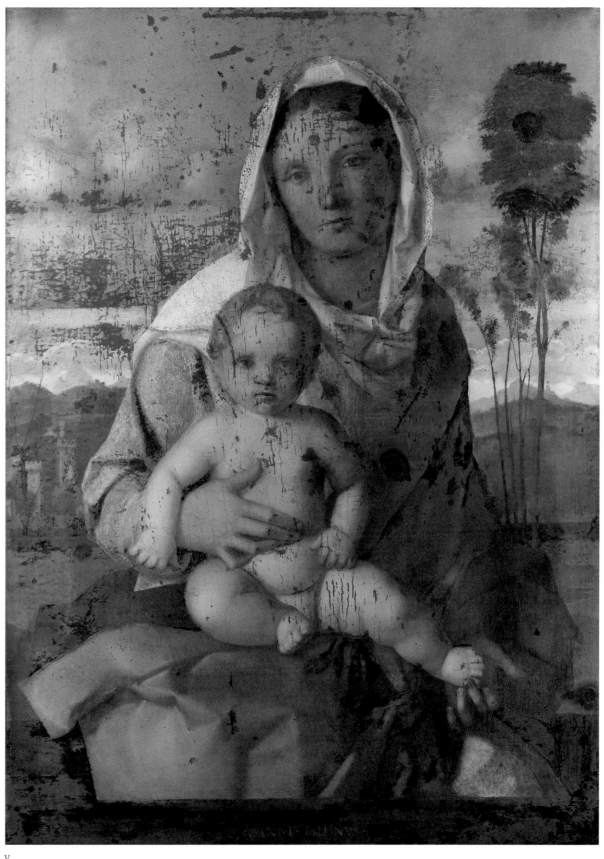

V

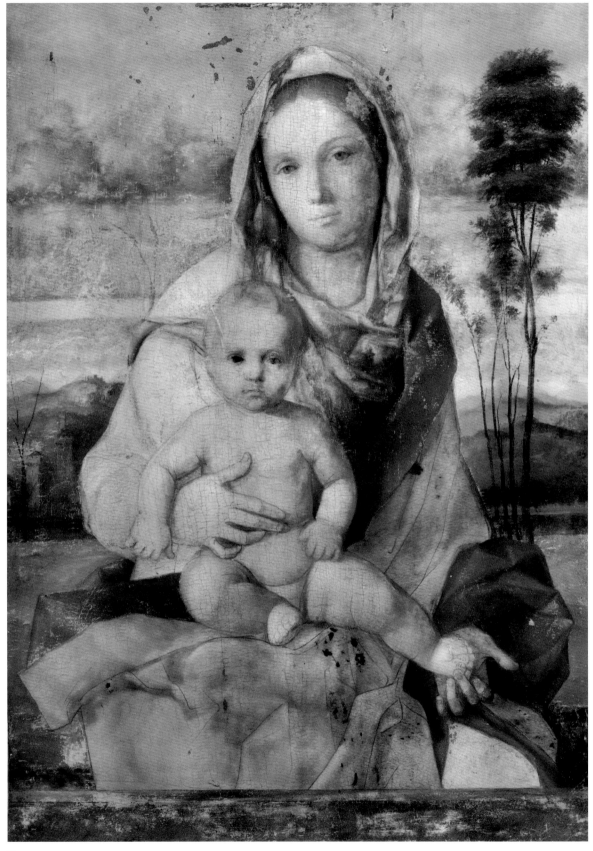

VI

APPENDIX I

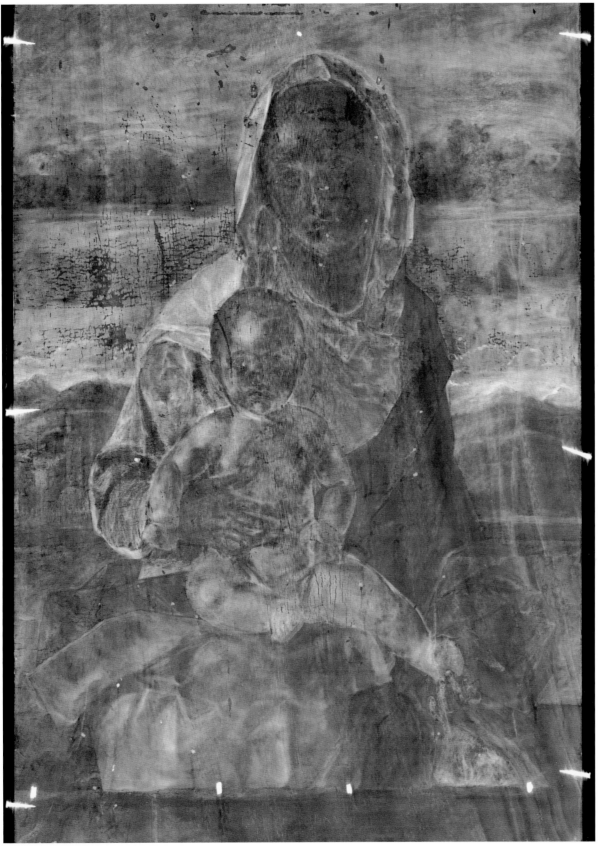

VII

Copies and Variants

A

Venetian (?), after Giovanni Bellini
The Madonna and Child, 16th century (?)
Panel, 65 × 50 cm
Rome, Santa Maria in Trastevere, Sala Capitolare

PROVENANCE

Rome, Santa Maria in Trastevere, from before 1907 until 1911; Rome, Galleria Borghese (on deposit), from 1911 until around 1930; Rome, Santa Maria in Trastevere, since around 1930

BIBLIOGRAPHY

CANTALAMESSA 1907; CANTALAMESSA 1908; *Cronaca* 1911, p. 480; GRONAU 1928, pp. 12, 34, note 6; GRONAU 1928-29, p. 62, note 1; GRONAU 1930, p. 158, no. 158, unnumbered fig. p. 215; VAN MARLE 1935, pp. 327-28, note 1; WATERHOUSE 1955, p. 295; BERENSON 1957, I, p. 33; PALLUCCHINI 1959, p. 155; HEINEMANN 1962, I, pp. 20-21, no. 61a, II, fig. 225; BOTTARI 1963, p. 32, under no. 110; GUIDONI 1999, pp. 31-32, unnumbered fig.; TEMPESTINI 2009, pp. 50, 64, fig. 63, p. 105, note 62

B

Venetian (?), after Giovanni Bellini
The Madonna and Child, 16th century (?)
Panel, 68.3 × 47.6 cm
Pasadena, Norton Simon Museum, inv. no. F.1965.1.004.P

PROVENANCE

Florence, Luigi Bellini, around 1900-05; London, Charles Dowdeswell, around 1906; Florence, Elia Volpi (1858-1938), around 1908 (?); Florence, Charles Alexander Loeser (1864-1928), from around 1910 until 1928; Florence, Eugenio Ventura, around June 1928; New York, Duveen Brothers, from June 1928 until 1965; Pasadena, Norton Simon Museum, since 1965

BIBLIOGRAPHY

CANTALAMESSA 1908; REINACH 1910, p. 427, fig. 1; GRONAU 1928, pp. 12, 34, note 6; GRONAU 1928-29, p. 62, note 1; GRONAU 1930, p. 215, under no. 158; VAN MARLE 1935, p. 328; GAMBA 1937, pp. 175-76, 194, unnumbered fig.; HEINEMANN 1962, I, pp. 20-21, nos. 61b, II, fig. 228, and 61d, II, fig. 229 (both are this picture); BOTTARI 1963, pp. 31-32, under no. 110; HEINEMANN 1991, p. 10, no. 61b; SECREST 2005, p. 411

C

Venetian (?), after Giovanni Bellini
The Madonna and Child, 16th century (?)
Panel, dimensions unknown
Whereabouts unknown (photos: Rome, Gabinetto Fotografico Nazionale, c 19374; New York, Frick Art Reference Library, 707-8 p3; Florence, Kunsthistorisches Institut, 43887)

PROVENANCE
Rome, Nella Bolognesi, around 1911; Milan, Foresti collection (?), around 1936 (?)

EXHIBITIONS
1911, Rome, Castel Sant'Angelo

BIBLIOGRAPHY
Guida generale 1911, pp. 137–38, unnumbered fig. p. 137; A.G. De Marchi, in ANGE-LELLI AND DE MARCHI 1991, p. 90, no. 156, fig. 156

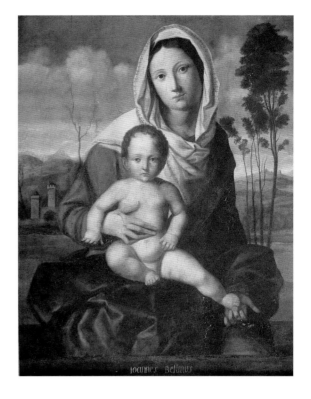

D

Venetian (?), after Giovanni Bellini
The Madonna and Child, 16th century (?)
Panel, 56 × 43.5 cm
Whereabouts unknown (photo: Venice, Fondazione Cini, Fondo Fiocco, 3786)

PROVENANCE
Florence, Sotheby's, 20 November 1981, lot 1326

BIBLIOGRAPHY
Catalogo 1981, no. 1326, repr.

E

Italian (?), after Giovanni Bellini
The Madonna and Child, 17th–18th century (?)
Panel, 54 × 42 cm
Whereabouts unknown (photos: Florence, Kunsthistorisches Institut, 424825; New York, Frick Art Reference Library, 10945)

PROVENANCE

Munich, A.S. Drey; Frankfurt am Main, Georg Kalischer, 1932; Cologne, Kunsthaus Lempertz, 18 November 1965, lot 217

BIBLIOGRAPHY

HEINEMANN 1962, I, pp. 20-21, no. 61c; *Alte Kunst* 1965, p. 36, n. 217; HEINEMANN 1991, p. 10, no. 61c

F

Italian (?), after Giovanni Bellini
The Madonna and Child, 17th–18th century (?)
Oil on paper, applied to canvas, 39 × 28 cm
Whereabouts unknown (photo: Florence, Kunsthistorisches Institut, 496091)

PROVENANCE
Trent (?), private collection, 1900s (?)

BIBLIOGRAPHY
Unpublished

Bibliography

AGLIETTI 1815
F. Aglietti, 'Elogio storico di Jacopo e Giovanni Bellini', in *Discorsi letti nella I. R. Accademia di Belle Arti di Venezia in occasione della distribuzione de' premi degli anni 1812. 1813. 1814. 1815*, Venice 1815, pp. 19–80

AGOSTI 1998
G. Agosti, 'Scrittori che parlano di artisti, tra Quattrocento e Cinquecento in Lombardia', in B. Agosti, G. Agosti, C.B. Strehlke and M. Tanzi, *Quattro pezzi lombardi (per Maria Teresa Binaghi)*, Brescia 1998, pp. 39–93

AGOSTI 2005
G. Agosti, *Su Mantegna I: La storia dell'arte libera la testa*, Milan 2005

AGOSTI 2009
G. Agosti, *Un amore di Giovanni Bellini*, Milan 2009

AGOSTI AND FARINELLA 1987
G. Agosti and V. Farinella (eds.), *Michelangelo e l'arte classica*, exh. cat. (Florence, Casa Buonarroti, 15 April – 15 October 1987), Florence 1987

Alte Kunst 1965
Alte Kunst: Kunstnachlass F.F. Uthemann, St. Petersburg-Genf, Teil I, v.a. Besitz: Gemälde und Skulpturen des 15. bis 19. Jahrhunderts, auct. cat. (Cologne, Kunsthaus Lempertz, 18 November 1965), Cologne 1965

ANGELELLI AND DE MARCHI 1991
W. Angelelli and A.G. De Marchi, *Pittura dal Duecento al primo Cinquecento nelle fotografie di Girolamo Bombelli*, ed. S. Romano, Milan 1991

Art Treasures 1957
Art Treasures Centenary: European Old Masters, exh. cat. (Manchester, City of Manchester Art Gallery, 30 October – 31 December 1957), Manchester 1957

ARTEMIEVA 2005
I. Artemieva, 'La Fuga in Egitto dell'Ermitage', in *Tiziano: Restauri, tecniche, programmi, prospettive*, ed. G. Pavanello, Venice 2005, pp. 3–15

ARTEMIEVA 2012
I. Artemieva, 'New light on Titian's "Flight into Egypt" in the Hermitage', *The Burlington Magazine*, CLIV, 2012, pp. 4–11

BALLARIN 1965
A. Ballarin, *Palma il Vecchio*, Milan 1965

BALLARIN 1968
A. Ballarin, 'Pittura veneziana dei musei di Budapest, Dresda, Praga e Varsavia', *Arte Veneta*, XXII, 1968, pp. 237–55

BALLARIN 1981
A. Ballarin, 'Giorgione: per un nuovo catalogo e una nuova cronologia', in *Giorgione e la cultura veneta tra '400 e '500: Mito, Allegoria, Analisi iconologica*, Rome 1981, pp. 26–30

BALLARIN 1994
A. Ballarin, *Dosso Dossi: La pittura a Ferrara negli anni del ducato di Alfonso I*, II, Cittadella 1994

BALLARIN 1995
A. Ballarin, *Dosso Dossi: La pittura a Ferrara negli anni del ducato di Alfonso I*, I, Cittadella 1995

BARAUSSE 2008
M. Barausse, 'Giovanni Bellini. I documenti', in *Giovanni Bellini* 2008, pp. 327–59

BENCI AND STUCKY 1987
J. Benci and S. Stucky, 'Indagini sulla pala belliniana della Lamentazione. Bonaventura da Forlì e i Servi di Maria a Venezia', *Artibus et Historiae*, VIII, no. 15, 1987, pp. 47–65

BERENSON 1895
B. Berenson, *Venetian Painting, chiefly before Titian, at the Exhibition of Venetian Art. The New Gallery, 1895*, London [1895]

BERENSON 1899
B. Berenson, *Amico di Sandro* [1899], ed. P. Zambrano, Milan 2006

BERENSON 1901
B. Berenson, *The Study and Criticism of Italian Art*, I, London 1901

BERENSON 1908
B. Berenson, *The Study and Criticism of Italian Art*, 2nd edn., London 1908

BERENSON 1957
B. Berenson, *Italian Pictures of the Renaissance: A List of the Principal Artists and their Works with an Index of Places: Venetian School*, 2 vols., London 1957

BEVILACQUA 1845
G.C. Bevilacqua, *Insigne pinacoteca della nobile veneta famiglia Barbarigo della Terrazza*, Venice 1845

BOSKOVITS 2011
M. Boskovits (ed.), *The Alana Collection: Newark, Delaware, USA: Vol. II: Italian Paintings and Sculptures from the Fourteenth to Sixteenth Century*, Florence 2011

BOTTARI 1963
S. Bottari, *Tutta la pittura di Giovanni Bellini: Volume secondo: 1485-1516*, Milan 1963

BURY 1989
M. Bury, 'The 'Triumph of Christ', after Titian', *The Burlington Magazine*, CXXXI, 1989, pp. 188–97

CALBI AND SCAGLIETTI KELESCIAN 1984
E. Calbi and D. Scaglietti Kelescian, *Marcello Oretti e il patrimonio artistico privato bolognese: Bologna, Biblioteca Comunale, Ms. B. 104*, Bologna 1984

CAMPANA 1962
A. Campana, *Notizie sulla "Pietà" riminese di Giovanni Bellini*, in *Scritti di storia dell'arte in onore di Mario Salmi*, II, Rome 1962, pp. 405–27

CANNON-BROOKES 1977
P. Cannon-Brookes, *The Cornbury Park Bellini: A contribution towards the study of the late paintings of Giovanni Bellini*, Birmingham 1977

CANTALAMESSA 1907
G. Cantalamessa, 'Pittura veneta in S. Maria in Trastevere', *Bollettino d'Arte*, I, 1907, pp. 16–18

CANTALAMESSA 1908
G. Cantalamessa, 'Ancora del quadretto di S. Maria in Trastevere', *Bollettino d'Arte*, II, 1908, pp. 104–06

Catalogo 1981
Catalogo di stampe, disegni, dipinti antichi, auct. cat. (Florence, Sotheby's, 20 November 1981), Florence 1981

Catalogue 1828
Catalogue of Pictures by Italian, Spanish, Flemish, and Dutch Masters [...], exh. cat. (London, British Institution, 1828), London 1828

Catalogue 1892
Catalogue of the Highly Important Gallery of Pictures of the Late Rt. Hon. Earl of Dudley, auct. cat. (London, Christie's, 25 June 1892), London 1892

CECCHINI 2007
I. Cecchini, 'Grimani Calergi, collezione', in *Il collezionismo d'arte a Venezia: Il Seicento*, ed. L. Borean and S. Mason, Venice 2007, pp. 278–80

Cronaca 1911
'Cronaca', *L'Arte*, XIV, 1911, pp. 479–80

CROWE AND CAVALCASELLE 1871
J.A. Crowe and G.B. Cavalcaselle, *A History of Painting in North Italy, Venice, Padua, Vicenza, Verona, Ferrara, Milan, Friuli, Brescia, from the Fourteenth to the Sixteenth Century*, 2 vols., London 1871

CROWE AND CAVALCASELLE (1912)
J.A. Crowe and G.B. Cavalcaselle, *A History of Painting in North Italy. Venice, Padua, Vicenza, Verona, Ferrara, Milan, Friuli, Brescia, from the Fourteenth to the Sixteenth Century* [1871], ed. T. Borenius, 3 vols., London 1912

DAVOLI 2006
Z. Davoli, *La raccolta di stampe 'Angelo Davoli'*, VI, Reggio Emilia 2006

DE MARCHI 1986
A. De Marchi, 'Sugli esordi veneti di Dosso Dossi', *Arte Veneta*, XL, 1986, pp. 20–28

DE VECCHI 1975
P.L. De Vecchi, 'Rocco Marconi', in *I pittori bergamaschi dal XIII al XIX secolo: Il Cinquecento: I*, Bergamo 1975, pp. 343–59

Exhibition 1871
Exhibition of the Works of the Old Masters, associated with Works of Deceased Masters of the British School, exh. cat. (London, Royal Academy of Arts, Burlington House, 1871), London 1871

Exhibition 1894
Exhibition of Venetian Art, ed. H.A. Grueber and I. Spielmann, exh. cat. (London, The New Gallery, 1894-95), London 1894

Exhibition 1955
Exhibition of Italian Art from the 13th century to the 17th century, exh. cat. (Birmingham, Museum and Art Gallery, 18 August - 2 October 1955), Birmingham 1955

FARA 1997
G.M. Fara, 'Sul secondo soggiorno di Albrecht Dürer in Italia e sulla sua amicizia con Giovanni Bellini', *Prospettiva*, no. 85, 1997, pp. 91-96

FARA 2007
G.M. Fara, *Albrecht Dürer: Lettere da Venezia*, Milan 2007

FARQUHAR 1855
[M. Farquhar], *Biographical Catalogue of the Principal Italian Painters with a Table of the Contemporary Schools of Italy: Designed as a Hand-Book to the Picture Gallery*, ed. R.N. Wornum, London 1855

FFOULKES 1895
C.J. Ffoulkes, 'L'esposizione dell'arte veneta a Londra', *Archivio storico dell'arte*, s. II, 1, 1895, pp. 70-86

FISCHER 1986
C. Fischer (ed.), *Disegni di Fra Bartolommeo e della sua scuola*, exh. cat. (Florence, Gabinetto Disegni e Stampe degli Uffizi, 1986), Florence 1986

FISCHER 1994
C. Fischer (ed.), *Fra Bartolomeo et son atelier: Dessins et peintures des collections françaises*, exh. cat. (Paris, Musée du Louvre, Cabinet des Dessins, 17 November 1994 - 13 February 1995), Paris 1994

FLETCHER 1971
J.M. Fletcher, 'Isabella d'Este and Giovanni Bellini's "Presepio"', *The Burlington Magazine*, CXIII, 1971, pp. 703-13

FLETCHER 2004
J. Fletcher, 'Bellini's Social World', in *The Cambridge Companion to Giovanni Bellini*, ed. P. Humfrey, Cambridge 2004, pp. 13-47, 274-81

FLETCHER AND MUELLER 2005
J. Fletcher and R.C. Mueller, 'Bellini and the Bankers: The Priuli Altarpiece for S. Michele in Isola', *The Burlington Magazine*, CXLVII, 2005, pp. 5-15

FRANKLIN 2001
D. Franklin, *Painting in Renaissance Florence: 1500-1550*, New Haven and London 2001

GAMBA 1937
C. Gamba, *Giovanni Bellini*, Milan 1937

Il Giardino 1992
Il Giardino di San Marco: Maestri e compagni del giovane Michelangelo, ed. P. Barocchi, exh. cat. (Florence, Casa Buonarroti, 30 June - 19 October 1992), Cinisello Balsamo 1992

GIBBONS 1962a
F. Gibbons, 'Giovanni Bellini and Rocco Marconi', *The Art Bulletin*, XLIV, no. 2, 1962, pp. 127-31

GIBBONS 1962b
F. Gibbons, 'The Bellinesque painter Marco Bello', *Arte Veneta*, XVI, 1962, pp. 42-48

GIORDANI 1830
G. Giordani, *Ornato della porta della nobil casa Salina in Bologna*, Bologna 1830

Giovanni Bellini 2008
Giovanni Bellini, ed. M. Lucco and G.C.F. Villa, exh. cat. (Rome, Scuderie del Quirinale, 30 September 2008 - 11 January 2009), Cinisello Balsamo 2008

GRONAU 1928
G. Gronau, *Spätwerke des Giovanni Bellini*, Strasbourg 1928

GRONAU 1928-29
G. Gronau, 'Le opere tarde di Giovanni Bellini', *Pinacotheca*, I, 1928-29, pp. 57-70, 115-31, 171-77

GRONAU 1930
G. Gronau, *Giovanni Bellini: Des Meisters Gemälde in 207 Abbildungen*, Stuttgart and Berlin 1930

Guida generale 1911
Guida generale delle mostre retrospettive in Castel Sant'Angelo, exh. cat. (Rome, Castel Sant'Angelo, 1911), Bergamo 1911

GUIDONI 1999
E. Guidoni, 'Vincenzo Catena: Catena e Giorgione, firme e rebus, nuove attribuzioni', *Studi giorgioneschi*, III, 1999, pp. 29-32

H.A. 1956
[H.A.], 'Birmingham: Arte italiana antica', *Emporium*, CXXIII, 1956, pp. 45-46

HAMILTON 1921
J.A. Hamilton, s.v. 'Ward, John William', in *The Dictionary of National Biography*, XX, London 1921, pp. 781-83

HEINEMANN 1962
F. Heinemann, *Giovanni Bellini e i belliniani*, 2 vols., Venice 1962

HEINEMANN 1991
F. Heinemann, *Giovanni Bellini e i belliniani: Volume III: Supplemento e ampliamenti*, Hildesheim, Zürich and New York 1991

HIRST 1981
M. Hirst, *Sebastiano del Piombo*, Oxford 1981

HOPE 1980
C. Hope, *Titian*, London 1980

HUMFREY 1990
P. Humfrey, 'Fra Bartolommeo, Venice and St Catherine of Siena', *The Burlington Magazine*, CXXXII, 1990, pp. 476-83

H.W. 1851
[H.W.], 'Lord Ward's collection of pictures', *The Athenaeum*, no. 1236, 5 July 1851, pp. 722-23

Italian Renaissance 1997
Italian Renaissance Art from Czech Collections: Drawings and Prints, ed. M. Zlatohlávek, exh. cat. (Prague, Národní Galerie, Grafická Sbírka, 12 December 1996 - 9 February 1997; Olomuc, Muzeum Umění Olmütz, 4 September - 26 October 1997), Prague 1997

JOANNIDES 2001
P. Joannides, *Titian to 1518: The Assumption of Genius*, New Haven and London 2001

Letters 1840
Letters of the Earl of Dudley to the Bishop of Llandaff, London 1840

LEVI 1988
D. Levi, *Cavalcaselle: Il pioniere della conservazione dell'arte italiana*, Turin 1988

LEVI D'ANCONA 1977
M. Levi d'Ancona, *The Garden of the Renaissance: Botanical Symbolism in Italian Painting*, Florence 1977

LLOYD 1993
C. Lloyd, *Italian Paintings before 1600 in the Art Institute of Chicago: A Catalogue of the Collection*, Chicago 1993

LONGHI 1927
R. Longhi, 'Un chiaroscuro e un disegno di Giovanni Bellini' [1927], in *Saggi e Ricerche: 1925-1928*, I, Florence 1967, pp. 179-88

LONGHI 1928
R. Longhi, 'Precisioni nelle gallerie italiane: La Galleria Borghese' [1928], in *Saggi e Ricerche: 1925-1928*, I, Florence 1967, pp. 265-66

LONGHI 1949
R. Longhi, 'The Giovanni Bellini Exhibition' [1949], in *Ricerche sulla pittura veneta: 1946-1969*, Florence 1978, pp. 99-109

LUDWIG AND BODE 1903
G. Ludwig and W. Bode, 'Die Altarbilder der Kirche S. Michele di Murano und das Auferstehungsbild des Giovanni Bellini in der berliner Galerie', *Jahrbuch der Königlich Preussischen Kunstsammlungen*, XXIV, 1903, pp. 131-46

Mantegna 2008
Mantegna 1431-1506, ed. G. Agosti and D. Thiébaut, with assistance from A. Galansino and J. Stoppa, exh. cat. (Paris, Musée du Louvre, 26 September 2008 - 5 January 2009), Milan 2008

MARCHESE et al. 1849
[V. Marchese, C. and G. Milanesi, C. Pini], 'Commentario alla Vita dei Bellini. Altre opere dei tre pittori Bellini dal Vasari non rammentate', in G. Vasari, *Le vite de' più eccellenti pittori scultori ed architettori*, ed. V. Marchese, C. and G. Milanesi, C. Pini, V, Florence 1849, pp. 20-26

MARTINIS 2000
R. Martinis, 'Su un fregio all'antica. Un'ipotesi per Antonio Lombardo nel palazzo di Andrea Loredan a Venezia', *Arte Veneta*, LVI, 2000, pp. 16-37

MAZZOTTA 2009a
A. Mazzotta, *Andrea Previtali*, Bergamo 2009

MAZZOTTA 2009b
A. Mazzotta, 'Gabriele Veneto e un ritratto dimenticato di Giovanni Bellini', *Prospettiva*, nos. 134-35, 2009, pp. 2-24

MAZZOTTA 2012
A. Mazzotta, *Titian: A Fresh Look at Nature*, exh. cat. (*Titian's First Masterpiece: The Flight into Egypt*, London, National Gallery, 4 April – 19 August 2012), London 2012

MICHIEL 1521-43
[M. Michiel], *Notizia d'opere del disegno* [1521-43], ed. T. Frimmel, Vienna 1888

MILANESI 1878
G. Milanesi, 'Commentario alla Vita dei Bellini', in G. Vasari, *Le vite de' più eccellenti pittori scultori ed architettori*, ed. G. Milanesi, III, Florence 1878, pp. 175-82

MINARDI 2010
M. Minardi, 'Una Madonna poco nota di Giovanni Bellini: un approfondimento e il quesito di un prototipo perduto', *Arte Cristiana*, XCVIII, no. 859, 2010, pp. 269-78

MORETTI 1973
L. Moretti (ed.), *G.B. Cavalcaselle: Disegni da antichi maestri*, exh. cat. (Venice, San Giorgio Maggiore, Fondazione Cini, 1973; Verona, Museo di Castelvecchio, 1973), Vicenza 1973

NEGRO AND ROIO 1998
E. Negro and N. Roio, *Francesco Francia e la sua scuola*, Modena 1998

Old Master 2010
Old Master & 19th Century Paintings, Drawings & Watercolours: Evening Sale, auct. cat. (London, Christie's, 6 July 2010), London 2010

OLIVARI 2001
M. Olivari, 'Tecnica pittorica e disegno preparatorio in Giovanni Bellini e Mario [*sic*] Basaiti', in *Oltre il visibile: Indagini riflettografiche*, ed. G. Buccellati, A. Marchi and D. Bertani, Milan 2001, pp. 29-50

PALLUCCHINI 1959
R. Pallucchini, *Giovanni Bellini*, Milan 1959

PASSAVANT 1833
J.D. Passavant, *Kunstreise durch England und Belgien, nebst einem Bericht über den Bau des Domthurms zu Frankfurt am Main*, Frankfurt am Main 1833

PASSAVANT 1836
J.D. Passavant, *Tour of a German Artist in England: With Notices of Private Galleries, and Remarks on the State of Art*, 2 vols., London 1836

PEARCE 1986
D. Pearce, *London's Mansions: The Palatial Houses of the Nobility*, London 1986

PENNY 2008
N. Penny, *National Gallery Catalogues: The Sixteenth Century Italian Paintings: Volume II: Venice 1540-1600*, London 2008

PIGNATTI 1969
T. Pignatti, 'Catalogo delle opere', in *L'opera completa di Giovanni Bellini*, ed. R. Ghiotto and T. Pignatti, Milan 1969, pp. 85-110

Pinacoteca 1990
Pinacoteca di Brera: Scuola veneta, Milan 1990

PINCUS 2008
D. Pincus, 'Giovanni Bellini's Humanist Signature: Pietro Bembo, Aldus Manutius and Humanism in Early Sixteenth-Century Venice', *Artibus et Historiae*, XXIX, no. 50, 2008, pp. 89-119

REARICK 1998
W.R. Rearick, 'The Drawings of Vittore Belliniano', in *Per Luigi Grassi: Disegno e disegni*, ed. A. Forlani Tempesti and S. Prosperi Valenti Rodinò, Rimini 1998, pp. 48-63

REINACH 1910
S. Reinach, *Répertoire de peintures du Moyen Age et de la Renaissance (1280-1580)*, III, Paris 1910

RIDOLFI 1648
C. Ridolfi, *Le maraviglie dell'arte. Ovvero Le vite degli illustri pittori veneti e dello Stato* [1648], ed. D.F. von Hadeln, 2 vols., Berlin 1914

ROBERTSON 1954
G. Robertson, *Vincenzo Catena*, Edinburgh 1954

ROBERTSON 1968
G. Robertson, *Giovanni Bellini*, Oxford 1968

ROVERSI 1994
G. Roversi, *Il Palazzo Salina Amorini Bolognini: Storia e restauro*, Bologna 1994

RUPPRICH 1956
H. Rupprich, *Dürer: Schriftlicher Nachlass*, I, Berlin 1956

SECREST 2005
M. Secrest, *Duveen: A Life in Art*, Chicago 2005

SEGRE 2011
R. Segre, 'A rare document on Giorgione', *The Burlington Magazine*, CLIII, 2011, pp. 383-86

SEIDLITZ 1895
W. von Seidlitz, 'Die Austellung venezianischer Kunst in der New Gallery zu London im Winter 1894-95', *Repertorium für Kunstwissenschaft*, XVIII, 1895, pp. 209-16

Le Siècle de Titien 1993
Le Siècle de Titien: L'âge d'or de la peinture à Venise: Édition revue et corrigée, ed. M. Laclotte and G. Nepi Scirè, exh. cat. (Paris, Grand Palais, 9 March – 14 June 1993), Paris 1993

SKUBISZEWSKA 1995
M. Skubiszewska, *Katalog zbiorów Museum Narodowego w Poznaniu: Catalogue of the National Museum in Poznań collection: Malarstwo włoskie do 1600: Italian painting before 1600*, Poznań 1995

SOGLIANI 2002
D. Sogliani, *Le collezioni Gonzaga: Il carteggio tra Venezia e Mantova (1563-1587)*, Cinisello Balsamo 2002

STEINBERG 1983
L. Steinberg, *The Sexuality of Christ in Renaissance Art and in Modern Oblivion*, New York 1983

TEMPESTINI 1976
A. Tempestini, 'Recensioni. I pittori bergamaschi del primo Cinquecento', *Antichità viva*, XV, no. 5, 1976, pp. 56-63

TEMPESTINI 2009
A. Tempestini, 'I collaboratori di Giovanni Bellini', *Saggi e memorie di storia dell'arte*, no. 33, 2009, pp. 21-107

TOSATO 2002
D. Tosato, 'La collezione di Francesco Aglietti (1757-1836)', *Saggi e memorie di storia dell'arte*, no. 26, 2002, pp. 353-429

TRESIDDER 1992
W. Tresidder, 'A borrowing from the antique in Giovanni Bellini's "Continence of Scipio"', *The Burlington Magazine*, CXXXIV, 1992, pp. 660-62

VALENTINER 1928
W.R. Valentiner, 'Giovanni Bellini's Madonna and Child', *Bulletin of The Detroit Institute of Arts of the City of Detroit*, X, no. 2, 1928, pp. 18-22

VAN MARLE 1935
R. Van Marle, *The Development of the Italian Schools of Painting*, XVII, The Hague 1935

VASARI 1550 AND 1568
G. Vasari, *Le Vite de' più eccellenti pittori scultori e architettori nelle redazioni del 1550 e 1568*, ed. R. Bettarini and P. Barocchi, 6 vols., Florence 1966-87

VENTURI 1907
L. Venturi, *Le origini della pittura veneziana: 1300-1500*, Venice 1907

WAAGEN 1838a
G.F. Waagen, *Kunstwerke und Künstler in England und Paris*, 2 vols., Berlin 1838

WAAGEN 1838b
G.F. Waagen, *Works of Art and Artists in England*, 3 vols., London 1838

WAAGEN 1843
[G.F. Waagen], 'Notice sur quelques cabinets de tableaux en Angleterre (Détails extraits du Voyage artistique (en allemand) de M.C.F. Vaagen.)', *Bulletin de l'alliance des arts*, II, 1843, pp. 173-74

WAAGEN 1854
G.F. Waagen, *Treasures of Art in Great Britain: being an Account of the chief Collections of Paintings, Drawings, Sculptures, Illuminated Mss., &c. &c.*, 3 vols., London 1854

WALKER 1956
J. Walker, *Bellini and Titian at Ferrara: A Study of Styles and Taste*, New York 1956

WATERHOUSE 1955
E.K. Waterhouse, 'The Italian Exhibition at Birmingham', *The Burlington Magazine*, XCVII, 1955, pp. 292-95

WILDE 1974
J. Wilde, *Venetian Art from Bellini to Titian*, Oxford 1974